PRE-RAPHAELITES

DISCOVERING ART

The Life, Times and Work of the World's Greatest Artists

PRE-RAPHAELITES

K. E. SULLIVAN

BROCKHAMPTON PRESS

For Rick, because of everything

The author would like to acknowledge the following invaluable sources for this book:
Christopher Wood's *Pre-Raphaelites*, Timothy Hilton's *The Pre-Raphaelites*
and William Gaunt's *The Pre-Raphaelite Tragedy*.
Thanks also to Carey Wells, who brought it all together, Kate Whitehead, for her
outstanding collection of books, and Anne Newman, for her encouragement.

First published in Great Britain by Brockhampton Press,
an imprint of The Caxton Publishing Group,
20 Bloomsbury Street, London WC1B 3JH

ISBN 1 84186 095 6

Produced by Flame Tree Publishing,
The Long House, Antrobus Road, Chiswick, London W4 5HY
for Brockhampton Press
A Wells/McCreeth/Sullivan Production

Printed at Oriental Press, Dubai, U.A.E.

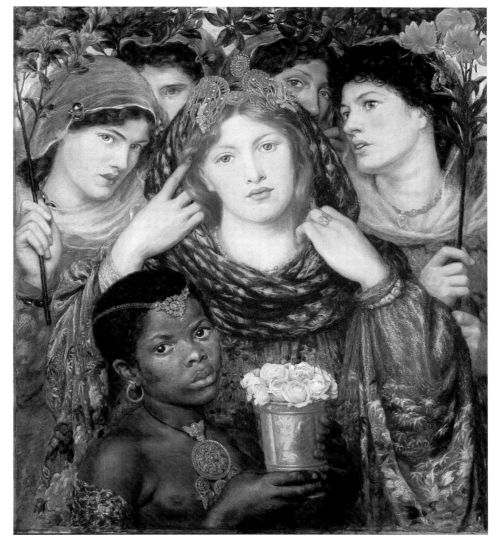

CONTENTS

The Beloved (The Bride), Rossetti, 1865–6 (Tate Gallery, London). This painting was finished after Lizzie Siddal's death, but she is the central figure. Rossetti was as obsessed by her in death as he was in life. One of the attendants was Rossetti's colleague, Frederick Sandys' lover, a woman known as Keomi, who appeared in several of the Pre-Raphaelites' work.

INTRODUCTION

In 1848, three young art students formed an alliance which would become one of the most influential and contentious movements in the history of the English art world. It was a shaky alliance, one founded on youthful visions, idealistic aspirations and confused aims, and it lasted only four years. But this alliance, or 'brotherhood' as it came to be called, became a revolutionary force in English art, changing its course and creating a following which carried its impact well into the twentieth century. This alliance was the Pre-Raphaelite Brotherhood; the three young men were Dante Gabriel Rossetti, William Holman Hunt and John Everett Millais, and their names are as famous today as the movement they created.

The story of the Pre-Raphaelites reads like the finest Gothic fiction; their story is rent with *femmes fatales*, drugs, suicides, religious fanaticism and the fervent idealism of cultured and learned young men. Some called the movement a tragedy; two of its members later denied any serious involvement. Others called the movement a dream, one which swept together the seedlings of change in a time when revolution in politics, in monarchies and in society was rife, when the intelligentsia of a nation grasped on to its pleasant ideals and allowed them to blossom.

The Pre-Raphaelites believed that art had taken a wrong turn around the time of Raphael (1483–1520), and they were determined, in the words of William Holman Hunt, to do 'battle against the frivolous art of the day', against 'approved imitations of the Greeks, and paintings that would ape Michelangelo and Titian'. They took their inspiration from the Italian masters of the Quattrocento, returning to the immaculate purity of Pre-Renaissance art. To them art had become florid and insincere, lacking in a moral seriousness that was necessary for it to be uplifting. Rossetti's brother William defined their aims as being:

1. To have genuine ideas to express;
2. To study Nature attentively, so as to know how to express them;
3. To sympathize with what is direct and serious and heartfelt in previous art, to the exclusion of what is conventional and self-parading and learned by rote; and
4. Most indispensable of all, to produce thoroughly good pictures and statues.

Their paintings were almost surreal in their pedantic realism, the colours more vibrant than anything contemporary, although they embraced the growing interest in fresco painting, in which bright colours were applied on a wet, white background to produce a luminous effect. Their outspoken use of colour, painted in thin layers, and with tiny brushes, reflects the passion with which they imbued their works, and the evenness of light and the extraordinary detail make

them unique even today. They painted some of the most beautiful women in art, creating the quintessential Pre-Raphaelite woman, with long, wavy tresses and a serene, almost challenging, expression. All of the initial members of the Brotherhood had their lives changed dramatically by the women they painted, by the women with whom they were to share their beds. These women are as much a part of the Pre-Raphaelite story as the painters themselves.

And that story begins in the summer of 1848, when Rossetti, a youth of intrinsic charm and charisma, met William Holman Hunt. Hunt was the son of a tradesman, and he was a dedicated and diligent painter. He expressed his religious fervour through his paintings and he was exceedingly unpretentious. Rossetti, on the other hand, was witty and enthusiastic. He was the contemporary Byron – poetic, dangerously handsome and extraordinarily persuasive – and it was his powerful influence which dominated the early days of the Brotherhood, and instigated its inception. Enter a third: Millais, the darling of the Royal Academy, a painter of accomplishment, fine integral talent, and a buoyant sense of fun.

This celebrated trio led lives that were characterized by drama, spectacular successes, breathtaking failures, and ultimately tragedy. The focus of their discontent was London's Royal Academy, and everything for which it stood. Single-handedly they were able to write a new chapter in its history, one which would reverberate around the country, lifting eyebrows and furrowing brows, until their philosophies became legend world wide.

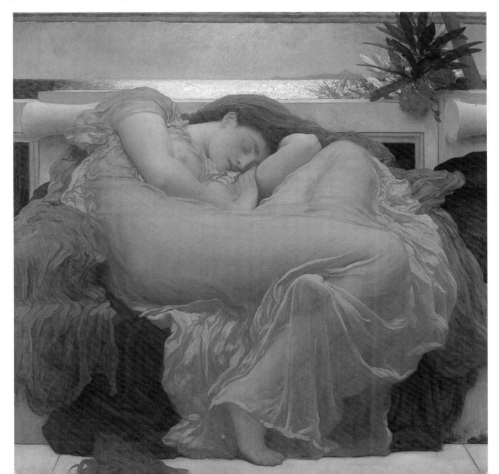

Flaming June, Leighton, 1895
(Ponce Museum, Puerto Rico).
A rich, sensuous painting, *Flaming June* embodies many elements of the Pre-Raphaelites, the pure, bright colour and the extraordinary use of light across the painting.

CHAPTER 1

The Brotherhood

By the mid-nineteenth century, the Royal Academy reigned supreme as the centre of the English art world. Housed in the buildings which would one day hold the National Gallery, in London's Trafalgar Square, it provided the means by which art was defined within the art establishment in England.

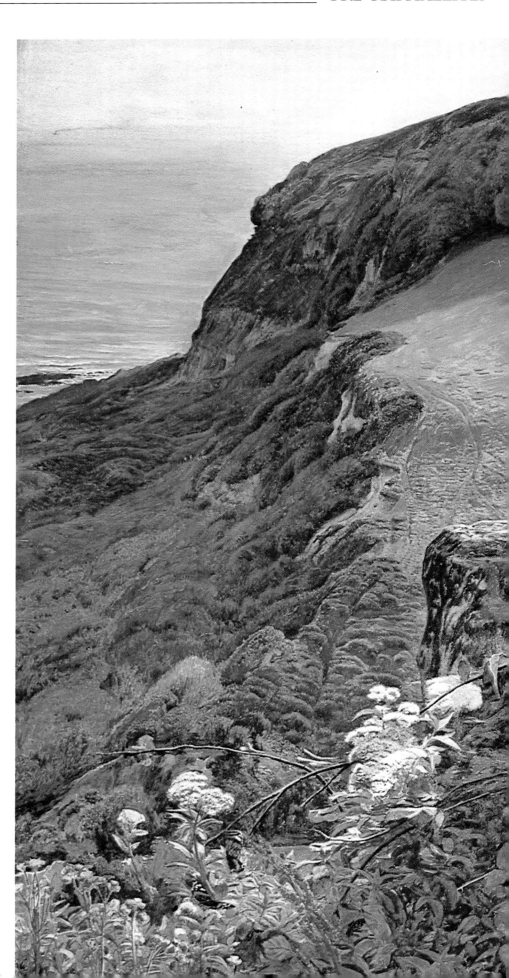

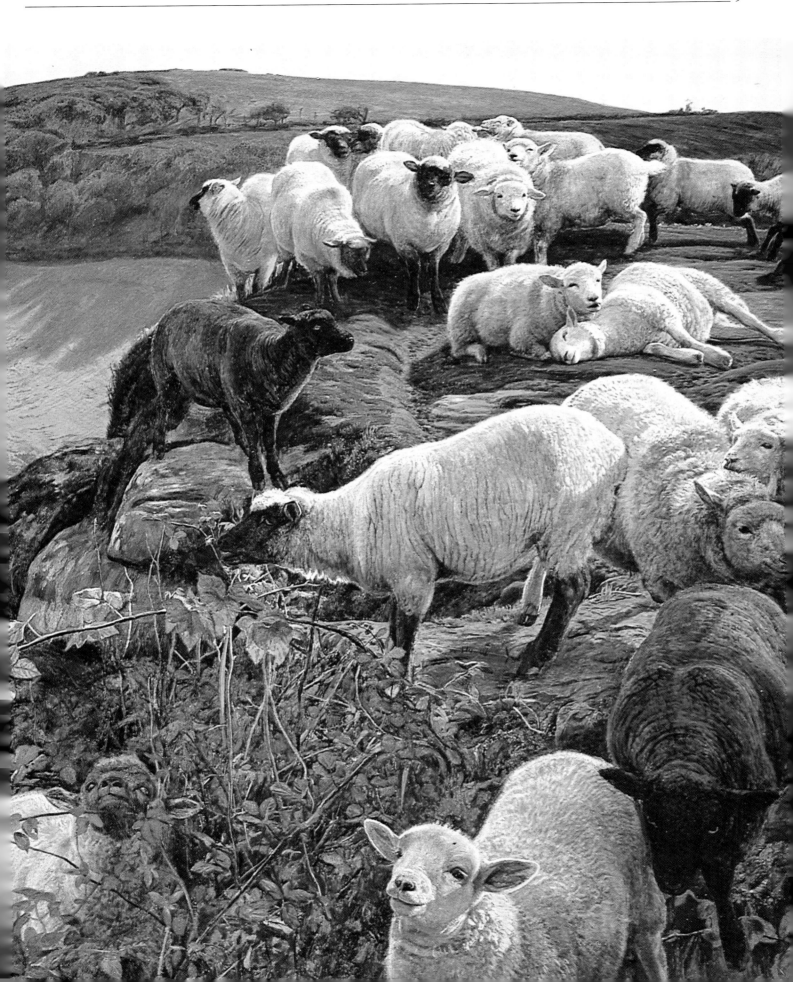

Overleaf:
Strayed Sheep (Our English Coasts), Holman Hunt, 1852 (Tate Gallery, London). Painted in 1852 and hung at the Royal Academy in 1853, this work caused Delacroix to write in his journals, 'I am really astounded by Hunt's sheep.' The coloration of this painting makes it one of Hunt's best landscapes.

Good art – at least as defined in the mid-nineteenth century – was based on techniques drawn from the Italian Masters, from Raphael and the Carraccis. Their subjects were considered the supreme embodiment of artistic integrity and careful and considered replicas of these paintings, worked in elaborate but dull colours, were what most artists of current sensibility strove for. But the Royal Academy was becoming stagnant. Most of its greatest painters had died. Only one painter of note, J.M.W. Turner, remained a member of the exclusive institution, but at sixty-eight, he was deemed by many of his contemporaries to be a part of the past, his earlier vibrancy giving way to what many considered to be a growing formlessness. But even Turner himself, a purist and great admirer of classical art, was dismayed by the austere limitations now accorded to art.

William Holman Hunt visited the Academy often. Although he was a conservative youth, not yet a member of the hallowed art establishment, he did not seek out the works of the Masters; instead, he found himself drawn irresistibly to the work of a young child prodigy, John Everett Millais, who had entered the Academy at the age of ten. Holman Hunt was born in 1827, of humble origins, and he struggled against poverty for most of his life. He worked as a clerk from the age of twelve, painting in his spare time and attempting to gain admittance to the Academy, which he failed to do on a number of occasions. He was finally admitted on probation in 1844 and he endeavoured at once to seek out Millais, whom he had admired so openly.

Hunt was eager but reserved. His religious conviction was often considered zealous, but he was firm in its defence and never wavered from his beliefs. He was a purist, dedicated to the betterment of society, an aim which he felt could be accomplished through art. His family did not encourage his art; indeed, they felt it trivial and wasteful in terms of both time and resources. He, however, strode on despite their constant discouragement. One of his early employers had been the reformer Richard Cobden. Hunt had vehemently disagreed with Cobden's views on free trade, but his example, as Hunt says in his autobiography, 'encouraged me to value the cultivation of a larger ambition than that of the mere making of a personal fortune'.

Hunt believed he understood the problems of society and he attempted to relay that message in his work, undertaking a kind of Christian socialism which ran throughout his entire *oeuvre* from *The Hireling Shepherd* (1851) onwards. *The Hireling Shepherd* represented, in Hunt's words, 'a rebuke to the sectarian vanities and vital negligences of the day'. Seemingly a pastoral celebration of young lovers, Hunt called his shepherd typical of the 'muddle-headed pastors who instead of performing their services to the flock – which is in constant peril – discuss vain questions of no value to any human soul'. But the painting is an exquisite representation of nature and the natural, a 'real

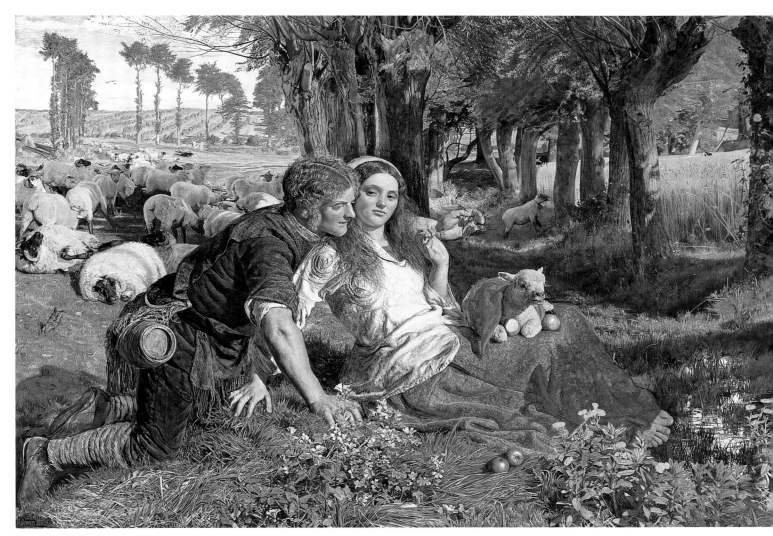

shepherd and a real shepherdess, and a landscape in full sunlight, with all the colour of luscious summer'.

The subject of Hunt's admiration, Millais, had been much fêted in the art world and he was the darling of the Academy. His family had come from Jersey, and Millais, or 'Johnny' as he was known to intimates, was born in Southampton, in 1829. His artistic gifts were undeniable and recognized at an early age; his parents moved the family to London to further his chances of success. He entered Sass's, the preparatory arm of the Academy Schools, and at the age of eleven entered the Royal Academy, charming art lovers with his wholesome paintings and attracting the attention of the establishment with his extraordinary skill. William Gaunt, in *The Pre-Raphaelite Tragedy*, described him as being:

> *... a quaint, angelic little creature – an Early Victorian angel. Long light curls fell over his goffered collar, his face was fresh-coloured and open, his eyes a candid blue. He wore a tunic with a cloth belt,*

The Hireling Shepherd, Hunt, 1851 (Manchester City Art Gallery). Hunt invested this painting with a moral seriousness; the shepherd represents the church, which has allowed its flock to run astray. This painting inspired many other Pre-Raphaelites.

The Eve of St Agnes, Hunt, 1848
(Walker Art Gallery, Liverpool).
This painting so impressed Rossetti that
he determined to meet Hunt and study
under him. It was the beginning of a
friendship which would spawn one of
the greatest schools of art.

short trousers above white socks and patent leather shoes. They passed him from hand to hand over the seats, while the students laughed and clapped and the platform smiled approval. 'The Child' was the darling of the institution, destined, it would seem, by nature, for all its honours

Millais had been adored by an indulgent and rather smothering mother who refused to allow him to go to school, tutoring him at home in subjects she found interesting or useful in books. His father, a musician, sat for dozens of portraits, playing the guitar while Millais painted. Even Millais' accommodating brother shared the family pride in Millais, and the aspiring artist flourished in the midst of such warm admiration and ambition on his behalf. He grew up confident and sparkling with wit and pleasure. It was to this happy home that Hunt was invited, and he relished the atmosphere, so different it was

from his own puritanical upbringing. 'Johnny's friend' was welcomed in the Millais household, and the two young men painted together – Millais learning poetry from the enthusiastic Hunt, and beginning to share his passion for interpreting verse on canvas. Only two years separated them, but Millais seemed much younger, having had a much easier childhood, and coming from a family slightly better off than Hunt's own.

They studied together, and shared, as they painted, their vision for art and their desire for change. They found a stalemate had been reached in contemporary art and they struggled to find the means by which it could be overcome. Hunt had discovered John Ruskin, and his *Modern Painters*, a series of books of criticism which championed Turner, and he found a voice for his vision. In these landmark writings, Ruskin had attacked what he considered the 'theatrical, affected and false, in art', encouraging all artists to 'Go to nature in all singleness of heart, selecting nothing, rejecting nothing'. Hunt felt those words had been written just for him.

Ruskin himself was an unusual and eccentric character. He was born in 1819 and had grown up in Herne Hill, a leafy suburb outside London, close to Dulwich College Picture Gallery and near enough to London for him to experience the cultural events it had to offer. He did not attend school; instead a series of tutors and classes with his parents presented him with a curious and varied education. He was a scholar, no doubt, but he was also a writer, critic, scientist and painter, with an over-riding interest in nature and all things natural. He was sternly

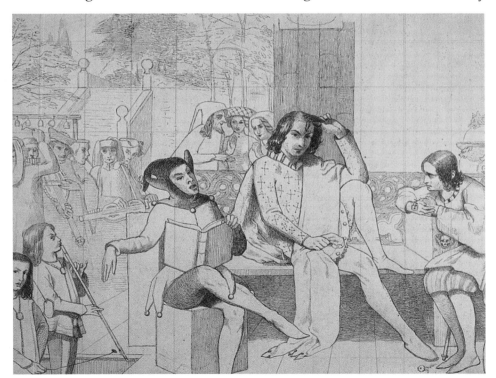

Twelfth Night, Deverell, 1850 (Forbes Magazine Collection). Deverell was a convert to Pre-Raphaelitism at its most controversial and almost unanimously criticized point. Lizzie Siddal is the model for Viola (left); and Deverell is reputed to have discovered her in a hat shop.

moral from an early age, and inflexible in his viewpoints. William Gaunt in *The Pre-Raphaelite Tragedy* wrote:

> *He was a puzzling individual. He puzzled his contemporaries as he has puzzled many since. The extravagance of his ... grandfather; the shrewdness of his father ... the rebelliousness of his grandmother ... the bigot in his mother: all these voices spoke through him with a Babel-like variety of opinion: the priggish voice of an only, sternly pampered son, the thundering intolerant voice of a Calvinist minister, the sane sceptic voice of a man of affairs, the gleeful puckish voice of a crazy imp.*

When his opinions were questioned he would go to great lengths to defend his stand, even if it meant publishing a book or a pamphlet to set the record straight. His *Modern Painters* was one such publication. Timothy Hilton, in *The Pre-Raphaelites*, wrote:

> *Ruskin's early writing about nature, as in the first two volumes of* Modern Painters *(1843 and 1846) is highly personal as well as precisely descriptive; and this is also true of his attitude towards art. His criticism is most successful when the two are brought most closely together. Turner's painting, for him, was beautiful because it was true;* Modern Painters *... is largely given over to the expansion of this idea. European painting of the post-Renaissance ... could not be anything but loathsome. Claude, Poussin, the classical masters of the landscape tradition ... the genre painters of the Dutch school ... are criticized with some vehemence, not as a man might kick away the curs that snap at his heels, but exhaustively, at great length ... with every instrument of castigation.*

William Holman Hunt shared these ideals and it was from here that the Pre-Raphaelites formed their original vision. Hunt and Millais shared the view that contemporary art was dull and empty, and that Raphael and the Grand Manner (a style of painting in which the subject transcends nature on an elevated plane) were overdone. Millais was a willing convert to Ruskin's convictions: with Hunt he sought out a new way of painting. It was at this time, in the year 1847, that a third member joined the idealistic twosome – someone with great eloquence, passion and fire, who had been ruminating about the state of art for some time. He was Dante Gabriel Rossetti, and it was his fervour and determination which brought the young men to the forefront of the art world.

Rossetti was born in London in 1828. His father was an exile from Italy, and a Professor of Italian at King's College, London, with a talent for pen and ink drawings and a flair for music, acting as librettist to the

The Awakening Conscience, Hunt, 1853 (Tate Gallery, London). Like he had in so many of his works, Hunt invested this painting with moral significance. He inscribed religious extracts around the frame and in the accompanying catalogue, but Victorian England was shocked by the overt reference to prostitution.

operatic theatre of San Carlo. The whole of Rossetti's family was imaginative and accomplished in the arts, pursuits encouraged by both parents. The household's conversation teemed with literary asides, poetic references and artistic analogies. It was a play house of the clever, eager and intelligent, and Rossetti was very much their leading man. He was darkly handsome, brooding one moment and laughing uproariously the next. William Gaunt described him as:

> ... *poetic in looks, after a rich, southern fashion; with an angular clean-shaven face, a dreamy gaze, full lips, hair waving to his shoulders and small, olive-coloured hands with delicately tapered fingers ... It was observable always in Rossetti that he flung out a net, with a sort of random deliberateness, here, there and everywhere, catching acquaintances, experience and ideas.*

Rossetti clipped snippets of poetry into every conversation, quoting the finest literature and inventing his own words and expressions in a jumble of engaging and musical near nonsense. He was enormously proficient both in painting and in poetry and these two passions fought one another for supremacy for the whole of his life. A childhood hero was William Blake, and he managed to acquire some early notebooks of Blake's prose, verse and designs, bought from an attendant at the British Museum with money borrowed from his brother.

Rossetti was quick-witted, easily bored. He left school at thirteen, entering Sass's, and four years later the Academy Schools, as a probationary student. The regimented teaching methods of the Academy failed to hold his attention and he increasingly missed classes. There was an urgency about his art; he was a passionate man and the dry, formal classes were unimportant to him. He wrote to the painter Ford Madox Brown an effusive epistle that was so outrageously complimentary that Madox Brown rose in a fury and, with cane in hand, arrived in person at Rossetti's home to uncover the sender of what he considered a hoax letter. He was astonished to find that the dreamy-eyed, sensuous Rossetti was serious, and he took him on as his student immediately.

Ford Madox Brown was an outstanding painter and much of his work anticipates the Pre-Raphaelite style. He was never a member of the Brotherhood, although many felt he should have been. His work was very structured, and he was a strict follower of the conventions made popular by the Royal Academy. Yet he had a fresh outlook and technique that heralded the Pre-Raphaelite use of colour and composition. Although he was only slightly older than Rossetti, he was firmly established and had received some good critical attention. Flattered by Rossetti's compliments and obvious appreciation of his work, Brown

The Empty Purse, 1857, James Collinson (Tate Gallery, London). Collinson was one of the original seven members of the Brotherhood, a creditable artist who undertook the ideology with alacrity, but lost interest and eventually resigned in 1850. He continued to paint in the Pre-Raphaelite style for much of his career.

set him to work drawing still-lifes that would refine his technique. Not surprisingly, Rossetti lost interest and the arrangement drew to a close, partly because Rossetti had wandered off in other directions and partly because Brown grew tired, as the story goes, of the papers Rossetti insisted upon using to clean his palettes, sticking to his boots when he returned home in the dark.

Rossetti had set his sights on a new goal. At the Academy exhibition that year, 1848, he saw a picture by another student, William Holman Hunt. It was called *The Eve of St Agnes* and it was this painting, based on Keats' poem of the same name, that sparked in Rossetti the fire that would fuel a new school of art. He turned his attentions to Holman Hunt with characteristic ardour.

Holman Hunt was astonished by Rossetti's courtship. He had seen Rossetti around with his entourage, but he had also noticed his sporadic attendance at the Academy and had doubted the seriousness of this rather wild young painter. Nevertheless, the two men spoke at length, and it was discovered that they shared a passion for Keats and the Romantic poets. Rossetti was a daunting partner. He quoted reams of poetry, living on the edge of his emotions, and caring little for the material gains his art might bring. He quivered with life, and knowledge. Hunt felt overpowered and yet somehow drawn to him. Within several days they had become friends.

Rossetti insisted that he begin to study under Hunt at once; he felt *The Eve of St Agnes* said everything about the way he wanted to paint. He was subsequently introduced to Millais and an instant bond formed between all three.

The young men began to hold regular meetings in London, either at Hunt's studio in Cleveland Street, at Millais' home in Gower Street, or in Rossetti's lively household, where members of the Rossetti family took turns interjecting their own opinions. The decision to form an artistic society was, perhaps, an arrogant one, but seemed natural in the light of their common aims. They coined the term 'Pre-Raphaelite' to describe themselves, since it reflected their belief that art had gone wrong three centuries earlier with the formal influence of Raphael and the Renaissance. Rebelling against the excesses and abuses of the art of the day, they determined to drop the aesthetic styles of the post-Raphael artists and bring about a new moral seriousness.

Being young and high-spirited, their aims were rather confused; their styles were diverse, but their energy and purpose drew them together. They strove to rediscover the purity and nobility in art, to adopt a naturalistic approach, based on vivid colours and exquisite detail. Although none of the three had actually been to Italy, they aspired to the honesty and simplicity of primitive Christian artists – in particular, Lasinio's engravings of fourteenth-century frescos in the Campo Santo at Pisa. They wanted to paint pictures, as Millais wrote,

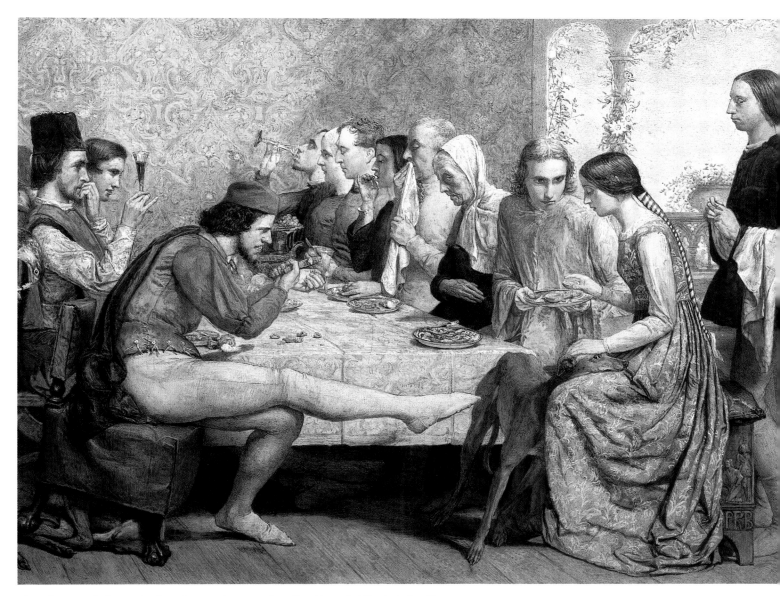

that 'turned the minds of men to good reflections'. Certainly they were inspired by the Nazarenes, a group of German artists who had lived in Rome since the early nineteenth century. There they had formed themselves into an almost monastic order in which to capture the artistic spirit, technique and symbolism of the early Italian and German painters, and so to rejuvenate religious art.

The three founding Pre-Raphaelites determined to go back to real life, to paint on the spot, out of doors, with complete fidelity to all things natural. Their figures would be painted from actual human beings, and, as Ruskin said, they would 'go to nature in all singleness of heart'. The academic teachings of the day were considered by the fledgling society to be slosh, and the previous president of the Royal Academy, Sir Joshua Reynolds, was nicknamed, Sir Sloshua.

There was a social conscience to their work; they were a pro-

Isabella, Millais, 1849 (Walker Art Gallery, Liverpool). This was Millais' first Pre-Raphaelite painting, which was exhibited in the Royal Academy in 1849. Based on a passage from Keats' *Isabella or the Pot of Basil*, this painting was praised at the first exhibition, before the significance of the initials PRB in the corner was recognized.

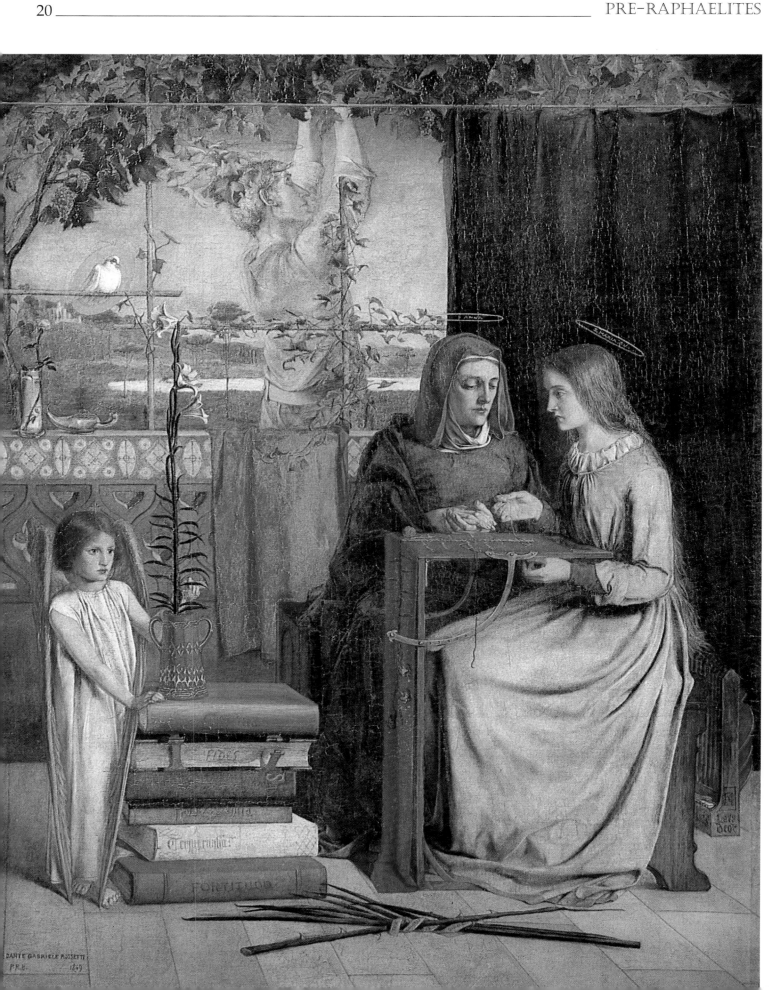

foundly idealistic group, and they felt that good art could draw attention to and perhaps right the social ills of the day. The plight of Victorian women in particular was addressed. Hunt, for instance, was bold enough to feature the problem of prostitution in *The Awakening Conscience*, and Madox Brown, in *Work* and *The Last of England*, focused on the predicament of the lower classes. In *The Pre-Raphaelites*, Christopher Wood explains:

> *Theirs was an intensely didactic, intensely moralistic art; it was also deliberately revolutionary – nothing else can explain its devastating effects on English nineteenth-century art. It was also a highly romantic art; the Pre-Raphaelites are unquestionably the Victorian heirs of the Romantic Movement. Ruskin revered Wordsworth; Hunt introduced the brotherhood to Keats; many of the pictures were based on romantic poetry, and almost all of them deal with romantic or tragic love.*

The Pre-Raphaelite society was to be secret, and accordingly they became a 'Brotherhood'. The group decided to exhibit publicly, keeping their identity undisclosed and ensuring that the initials 'PRB' appeared somewhere on the work to give strength to their union.

Four others had been invited to join the Brotherhood, not Madox Brown as one might have expected – his admittance was vetoed by Hunt who felt that Madox was too old (two years older than this group) and too academically inclined – but a rather unusual assortment of talents which lent little to this society. Rossetti was responsible for most of the newcomers. Thomas Woolner, an apprentice to the sculptor Behnes and assistant to medallion maker, Alexander Munroe, lived next door to Rossetti and was asked to join on the rather slim grounds that he believed in being true to nature, and he had a fondness for Shelley. He also had a showy pipe, which he puffed on to great effect. Next was James Collinson, the only one of the new members who was actually a painter. Collinson was a sleepy, overweight fellow, who became the focus of much amusement within the group. His paintings fitted the aims of the Brotherhood, in particular a work called *The Charity Boy's Debut*, and he denounced, upon request, all art after Raphael, promising cheerfully to deliver work that was true to the Brotherhood's aims.

Next was William Michael Rossetti, Rossetti's brother. He was an Inland Revenue clerk and, although he did not paint, he felt he might like to in the future, and that seemed to convince the other members of his worthiness. He later became a renowned critic and writer, but he had little to contribute other than idealism in those early days. The final member was Frederick George Stephens, who was a painter, although he had not actually completed a painting. He

The Girlhood of Mary Virgin, Rossetti, 1849 (Tate Gallery, London). This was Rossetti's first Pre-Raphaelite painting and the first to be inscribed with the initials of the Brotherhood, which was still a secret. Hunt's influence is evident in the religious imagery.

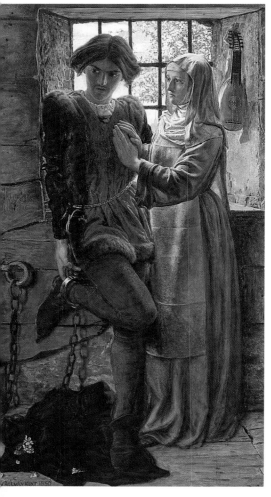

Claudio and Isabella, Hunt, 1850
(Tate Gallery, London). Hunt began this painting in 1850, but it was not hung at the Academy until 1853. The theme centres around Shakespeare's *Measure for Measure*, in which Isabella is implored by her brother Claudio to relinquish her honour in order to save him.

too became a writer later in his career, but for the time being, he was compelled by the Pre-Raphaelite rebellious spirit and he joined with great enthusiasm.

In retrospect the joint objectives of the group might arouse some mirth. William Gaunt explains their rather contradictory and high-minded ideals:

> He [Rossetti] had some cloudy vision of a great union of the arts, except music, which bored him: of a whole population of painters ... an ascetic community of 'art catholics' ... They would abjure bohemianism, swearing and drinking: rescue fallen women; and, perhaps with a dispensation in favour of Woolner, they would not smoke.

A list of 'immortals' was created, with a star system denoting their relative importance. This curious list was topped by Jesus Christ, and contained the likes of Homer, Joan of Arc, Elizabeth Barrett Browning, Columbus, Tennyson and King Alfred.

By the summer of 1849, the first paintings signed 'PRB' were hung. Rossetti's *The Girlhood of Mary Virgin* was exhibited at the Free Exhibition before the official Academy show. It was a lustrous, serious work, paying tribute to the techniques of the early Italian masters, and it was met with approval by the establishment. A month later, at the Academy show, Millais, Hunt and Collinson received similar encouragement from the critics for *Isabella, Ferdinand Lured by Ariel* (both by Millais), Collinson's *Italian Image-Makers at a Roadside Alehouse*, and Hunt's *Rienzi*.

Millais' *Isabella* in particular was lauded by the critics; each member of the Brotherhood had contributed a design to illustrate Keats' poem 'Isabella or the Pot of Basil', 'executed entirely on our new principles'. Millais' work was a vibrant blend of naturalism and conscious style, a tribute to their fresh approach to art and a celebration of his clearly superb technique. The *Art Journal* noted, 'a pure aspiration in the feeling of the early Florentine school ... cannot fail to establish the fame of the young painter'.

Rossetti was gleeful. He was so pleased that he wrote to Millais confirming that the success of the Brotherhood was now 'quite certain'. No one noticed that the initials 'PRB' had not been mentioned by the critics.

Rossetti, in a burst of his normal, unthinking enthusiasm, let out their big secret. He confided in a friend that this successful young group of artists was indeed a secret brotherhood. The game was lost before it could go any further. The critics stormed down on the bewildered Brotherhood. The following year, in 1850, the Brotherhood published a quarterly magazine called *The Germ* – an astonishingly

badly received idea which had been intended to work as propaganda for the society, but which backfired to such an extent that they hurriedly withdrew it after only four issues.

The Free Exhibition in the spring of that year included Rossetti's *Ecce Ancilla Domini*, and a new convert to the Brotherhood, Walter Howell Deverell's *Twelfth Night*. At the same time, the *Illustrated London News* published a piece about the Brotherhood, saying:

> Has the casual reader of art criticism ever been puzzled by the occurrence of three mysterious letters as denoting a new-fashioned school or style in painting lately come into vogue? The hieroglyphics in question are PRB and they are the initials of the words Pre Raffaelite [sic] Brotherhood.

And, continuing, the magazine called them 'practitioners of Early Christian Art [who] devoted their energies to the reproduction of saints squeezed out perfectly flat.'

The Royal Academy exhibition a few months later was fodder for

Christ in the House of His Parents, Millais, 1850 (Tate Gallery, London). Shown at the second exhibition of Pre-Raphaelite works at the Royal Academy, this painting raised the ire of more than one critic. Dickens called it 'mean, repulsive and revolting', but it has become one of the most famous works of the period, and of the Brotherhood.

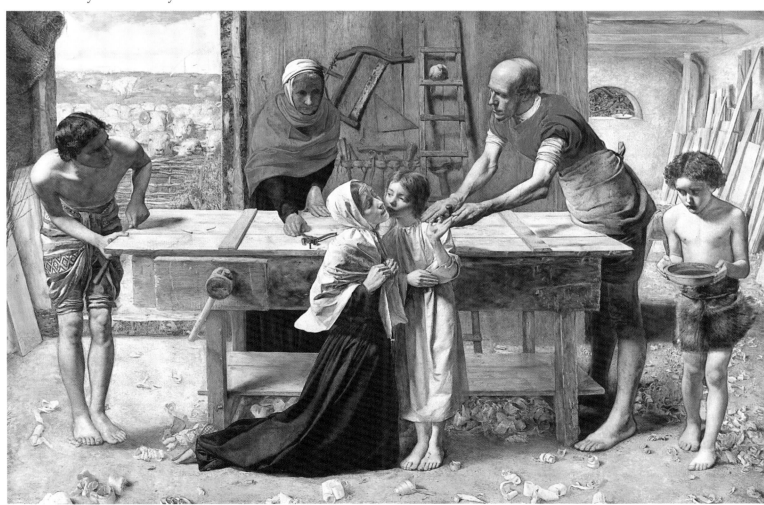

**Ecce Ancilla Domini
(The Annunciation), Rossetti, 1850**
(Tate Gallery, London). Rossetti's
second painting was so universally
disliked that he refused to exhibit in
London again. His sister, Christina, is
the model, as she was for many of his
early works.

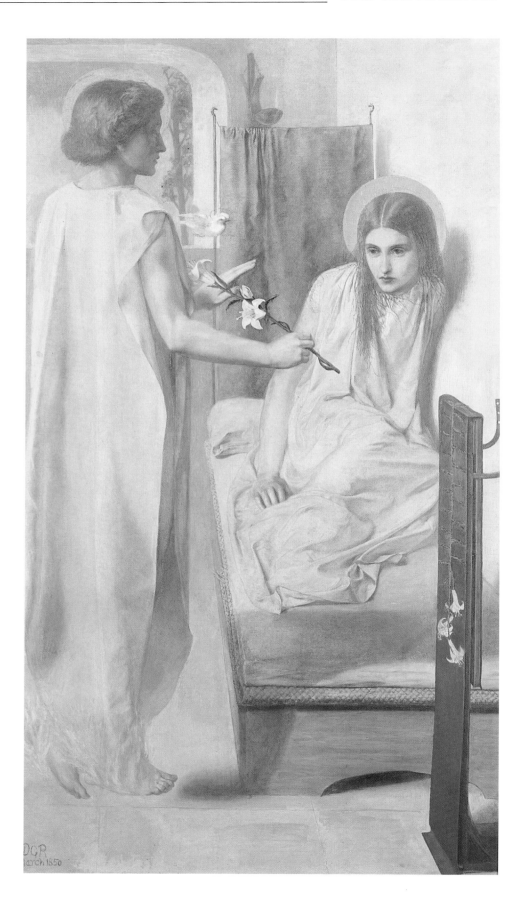

the venomous critics, who leapt into the fray with abandon scarcely seen in the dull days of Academy-led art.

Millais was the most heavily attacked, although Hunt, Collinson and others were universally slammed. Millais shrunk under the assault of critics from papers like *The Times*, who wrote that the picture *Christ in the House of His Parents* was 'plainly revolting'. Charles Dickens, in his journal *Household Words*, wrote:

> *You behold the interior of a carpenter's shop. In the foreground of that carpenter's shop is a hideous, wry-necked, blubbering, red-haired boy in a nightgown, who appears to have received a poke playing in an adjacent gutter, and to be holding it up for the con-templation of a kneeling woman, so horrible in her ugliness that (supposing it were possible for any human creature to exist for a moment with that dislocated throat) she would stand out from the rest of the company as a monster in the vilest cabaret in France or in the lowest gin-shop in England.*

None of the paintings of the Brotherhood was sold, and blame for the disaster flew among the colleagues. Millais was certain that Rossetti had leaked the story on purpose, and Rossetti was so incensed by the reactions that he swore never to exhibit in public again. Millais' parents were furious that their golden boy had become the object of such scorn, and they blamed Rossetti for leading him astray. 'That sly Italian,' said Mrs Millais, 'I wish Johnny had never met him.' Collinson resigned from the Brotherhood and Hunt was forced to consider giving up painting altogether, in the light of the financial difficulties he was experiencing. Hunt was never a prolific painter. The few paintings which he finished were essential for his meagre income and without a sale he was penniless.

It was a turning point for the infant Brotherhood and one which sent Rossetti off on a course of his own, to rejoin with the group's objectives at a later date. Hunt and Millais, however, were firmly entrenched in the new philosophy. In the end Millais chose to ignore the critical brouhaha, secure in the knowledge that he was a good painter and sustained by the fact that, in principle, the main members of the Brotherhood were supportive of one another. In the Royal Academy exhibition of 1851, the Pre-Raphaelites returned with a vengeance. And slowly, with great effort, the tide began to turn.

CHAPTER 2

Inspiration and the Inspired

There was not a universal dislike for the early work of the Pre-Raphaelites; indeed, it is more likely that it was the arrogance of creating a secret society which raised the ire of the critics rather than the paintings themselves.

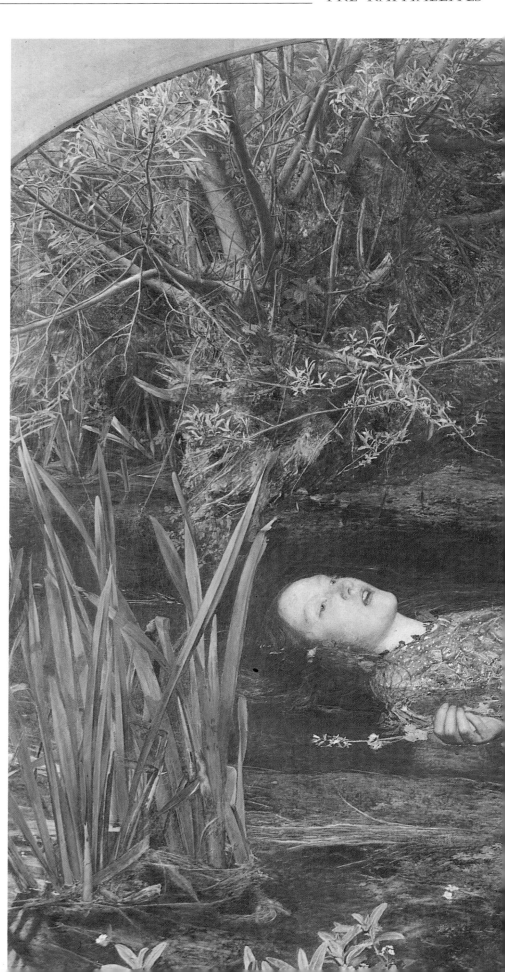

The devotees of the Pre-Raphaelites came out timidly at first, and then in force, well before the danger had passed. Artists risked their careers by speaking in favour of a movement which had been invariably shunned, but the strength of the Pre-Raphaelites is evident in the number of painters willing to do so. Walter Howell Deverell was one such supporter of the Brotherhood, although he never became a member. He too shared an interest in literary subjects, and his work is in tune with much of what the movement stood for. Charles Alston Collins was similarly moved, and, perhaps most important of all, so was the artist Arthur Hughes, who was one of the few converted after reading *The Germ*.

Arthur Hughes was a devout Pre-Raphaelite, although never a member of the Brotherhood. He was a quiet and understated man, but his paintings were some of the most famous and admired of the movement. Hughes was very much a follower. He was so impressed by what he read that he ingratiated himself with Rossetti and Hunt and began immediately to paint in their style. He was born in London, entering the School of Design under Alfred Stevens. He moved to the Academy Schools in 1847 and there he was quietly successful, winning a silver medal for his art two years later.

His first Pre-Raphaelite painting was *Ophelia*, which was hung at the Royal Academy Exhibition in 1852. Its jewel-like colours and theme of tragic, passionate love are perfectly in keeping with the group. He was attracted to the Brotherhood at a time when they were receiving nothing but antagonistic reviews and critical disdain. For a shy youth it was a courageous step to join their ranks.

The 1851 Royal Academy Exhibition had, if possible, attracted even harsher criticism. Millais had contributed the most: *Mariana, The Woodman's Daughter* and *The Return of the Dove to the Ark*, all of which were hailed as artistic misfits. Madox Brown's *Chaucer* was hung, and Hunt's *Valentine Rescuing Sylvia*, but *The Times* was first to attack, saying:

> *We cannot censure at present as amply or as strongly as we desire to do, that strange disorder of the mind or the eyes, which continues to rage with unabated absurdity among a class of juvenile artists who style themselves PRB ... [their] absolute contempt for perspective and the known laws of light and shade, an aversion to beauty in every shape, and a singular devotion to the minute accidents of the subjects.*

This stance was echoed by the rest of the press and critical establishment, with the unnotable exception of William Michael Rossetti's contribution to *The Spectator*, and even that was rather cautious in its praise. The Pre-Raphaelite style and technique seemed to inspire

The Woodman's Daughter, Millais, 1851 (Guildhall Art Gallery, London). This painting was exhibited at the Academy in 1851, and is based on a poem of the same name by Coventry Patmore, who was to become a friend of Millais, and eventually introduce him to Ruskin.

nothing but rancour from reviewers, but there seemed to be little substance to the attack.

The vivid colours of the Pre-Raphaelite paintings were achieved through the use of flat expanses of pure, bright colour, painted on a set white background, which makes the paintings appear almost illuminated. The design would be outlined on the canvas, with the white paint set over it, then painted, with the smallest of brushes and in meticulous detail, at an excruciatingly slow rate. This detail and use of light as an expanse rather than an accent was almost universally panned by the art critics of the day.

The group took many of their subjects from literature, particularly the poetry of the Romantic age. Hunt, for example, found inspiration in the work of Keats, and Shakespeare featured in the work of Hunt and Rossetti. A large number of their paintings are literary, as opposed to those conceived as 'art for art's sake', and this is evident from the explanations that accompanied them. Hunt, in particular, wrote at length to explain the symbolism of his paintings; his *Lady of Shalott* took over 700 words to describe in a catalogue accompanying the exhibition.

Medieval themes formed the basis for many of the paintings: such an extraordinary paradoxical view of art was held by the Pre-Raphaelites that they considered the essence of modernity to be found in paintings of the Middle Ages. They returned to the style and spirit of early Italian masters, like Giotto, Orcagna and Ghirlandaio, focusing on biblical, mythological and medieval stories. Their religious iconography provoked fears that they might be Roman Catholic, which was viewed with great horror in Victorian England.

Following the exhibition of 1851, the Pre-Raphaelites had reached their lowest point. Then help came in the form of a man of quite astonishingly Pre-Raphaelite intellect, considering he had no ties with the group. The Brotherhood cared little for John Ruskin, but they marvelled that they had not attracted his attentions earlier. At only thirty-two years of age Ruskin was the greatest art critic of the day. He now became the group's champion, setting himself in their midst and single-handedly turning their fortunes round. The story is that he took a shine to Millais' *Return of the Dove to the Ark,* and wished to purchase it. An acquaintance was made, and Ruskin was convinced by the poet Coventry Patmore to leap to their defence. Two letters were duly written to *The Times*, the second more effusive than the first, as he warmed to his subject. He said that the Pre-Raphaelites may, 'as they gain experience, lay in our England the foundation of a school of art nobler than the world has seen for three hundred years'.

Ruskin's involvement could not have come at a better time. Several satisfying and prolific years of work had ended with very little by way of financial remuneration. The Brotherhood were painting what to them represented perfect art, and with subjects, themes and models who inspired them enormously. It would have been a tragedy to give up at this point in their careers, but it looked like a necessary step. Millais was growing uneasy about his position with the Academy, and Hunt was drawing near to abject poverty. But Ruskin's approval changed everything and they continued in their revolutionary vein, painting increasingly dramatic and exquisite works, rich with colour and elaborate detail.

Next to enter the stage was the quintessential Pre-Raphaelite woman. Elizabeth ('Lizzie') Siddal was discovered by Deverell working

in a milliner's shop off the Strand, and she sat as his model for Viola in his *Twelfth Night*. She was quickly adopted by the group as a favourite model and she appeared in dozens of their early works; her face is instantly identifiable. She was a pale, sensual beauty, with a lustrous mass of long red hair and a profound, serene expression. Born to a cutler on the Old Kent Road, and, like most women of her day, largely uneducated, she was somewhat daunted by the attentions of these cultured young men, but her silent serenity earned her considerable admiration and respect. It also earned her the passionate devotion of Rossetti.

Rossetti and his colleagues were female connoisseurs, searching for the perfect woman for their works and, usually, for their beds too. They occasionally fell upon a 'stunner', and the term became synonymous with beautiful women. There seemed an inordinate amount of attention given to Pre-Raphaelite models, but this is best explained by Timothy Hilton:

> ... generally the Pre-Raphaelites did not paint portraits for gain but because they liked the people they painted. Pre-Raphaelitism completes the process, initiated in Romantic art, whereby the artist came to regard his sitter as an equal. The final and logical outcome of this tendency is in the portrait as an expression of love, in Millais' drawings of Effie Ruskin, in Rossetti's many delineations of Lizzie Siddal and Jane Morris. The Pre-Raphaelites delighted in portraying each other.

Lizzie Siddal featured more and more frequently in Rossetti's work and as he fell under her spell he refused to allow her to sit for his colleagues, claiming her as his own and eventually moving in with her in 1852, in Chatham Place, near Blackfriars Bridge in London. She had modelled for many of his contemporaries, including Millais who used her for his *Ophelia* – for which she had had to lie in an ever-colder bath of water for hours in order that he would be able to recreate the right effect – and Hunt who depicted her in *Valentine Rescuing Sylvia*. Rossetti's nickname for Lizzie was 'Guggums' and she became a vessel for his ideas, his passion and eventually his talents. Madox Brown wrote in 1855, 'Rossetti showed me a drawer full of "Guggums"; God knows how many ... Many of them are matchless in beauty ' She appeared in almost every Rossetti work, including *Dantis Amor, The Wedding of St George and the Princess Sabra,* and *Beata Beatrix,* among others.

Ruskin called Lizzie, 'beautiful as the reflection of a golden mountain in a crystal lake'. She embodied everything Rossetti had ever sought, in her cool, ardourless demeanour, and soulful expressions. She was inspired, under Rossetti and Ruskin, to paint, and she did

Ophelia, Hughes, 1865 (Toledo Museum of Art). This was Hughes' second version of the same painting: the first (1852) had a more haunting, ethereal quality to it, whereas this painting was a sensual and full-bodied portrayal of Ophelia, rendered in splendid Pre-Raphaelite colours.

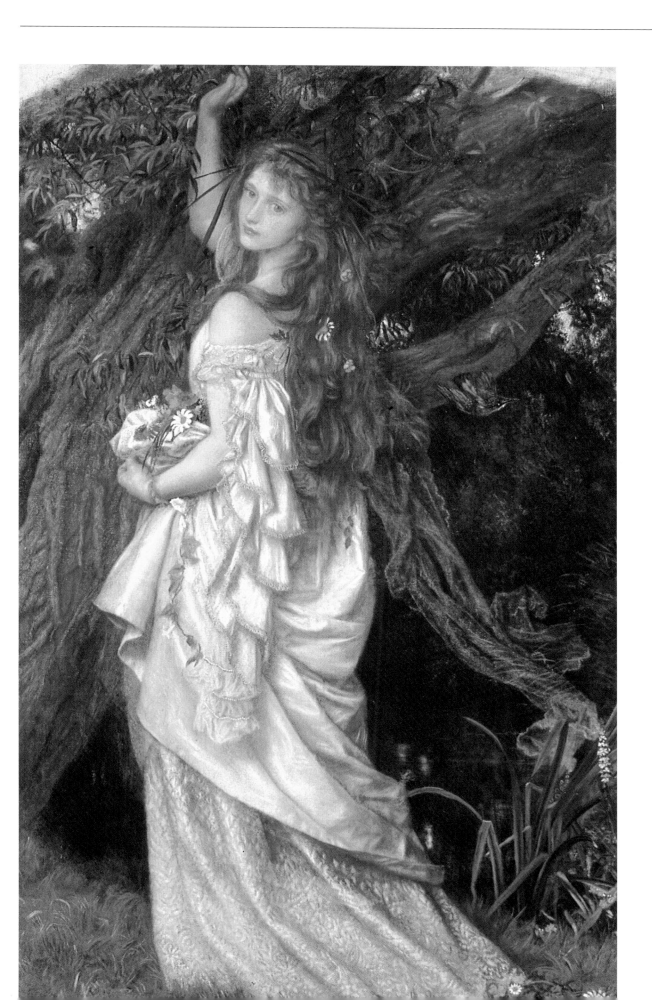

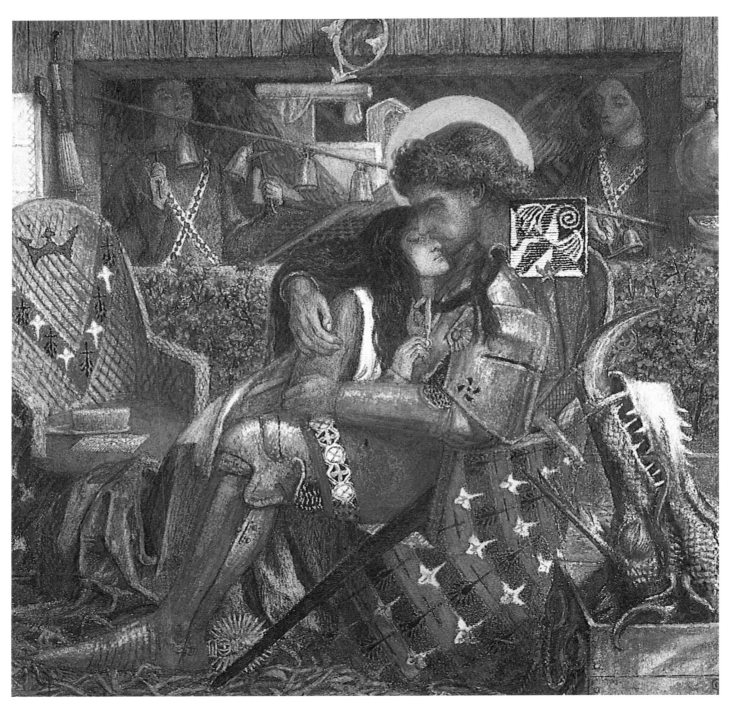

**The Wedding of St George and
Princess Sabra, Rossetti, 1857**
(Tate Gallery, London). The theme for
this enormously well received painting
is medieval. As a watercolour, the
richness of the golds and jewel tones
seem almost impossible.

some quite creditable work. She wrote poetry – slim enchanting verse which was encouraged by her Svengali but little understood by him.

Lizzie's health was poor, however, and her constitution unsteady. She wilted under the arduous affections of Rossetti, and he veritably drained the life from her. Rossetti had not chosen to marry Lizzie, and neither had he curbed his enormous appetite for women. He had taken another model, a robust, raucous young woman named Fanny Cornworth, a high-spirited Cockney professional model who was as

ill-mannered and loud as Lizzie was complacent. Lizzie sought peace and good weather to ease her constant ill health, but she wrote, from Nice, that '... one can get to the end of the world; but one can never be let alone or left at rest'. Her doctor diagnosed her condition as being caused by 'mental power long pent up and lately overtasked'. Fanny, nicknamed 'Elephant' by an adoring Rossetti, took over as model and mistress, while Lizzie languished in bed, sharing a home and her heart with Rossetti, but sharing Rossetti himself too.

Millais had also found himself in an extraordinary position, which had begun innocently enough, but which had ended in a rather sordid affair. Ruskin had made Millais' acquaintance about a matter involving a certain painting. He made no secret of his admiration for Millais' work and fancied that he could make him into the next Turner. He had not counted on the independent spirit of Millais, who had been cosseted and revered from such an early age that he was extremely self-confident and unwavering in his vision. He refused Ruskin's invitation to visit Switzerland, Ruskin's holy land because of its associations with Turner and his belief that it represented Nature at her most magnificent. Instead Millais stayed in Surrey to paint for the 1852 Academy exhibition with Hunt. Rossetti at this time was deeply entrenched in his female worship and although he continued to paint, he stood by his earlier vow not to exhibit again. He turned to literature for his subjects, shunning landscapes and religious works, combining his two great loves in the arts and painting Shakespeare, Keats and his namesake Dante.

Millais' *Ophelia* was sent to the Academy, and Hunt painted *The Hireling Shepherd,* one of his most important Pre-Raphaelite works. Ford Madox Brown, also painting in the Pre-Raphaelite style, exhibited *The Pretty Baa-Lambs* and *Christ Washing Peter's Feet.* Hunt went on to win an important prize at the Liverpool exhibition for his *Valentine Rescuing Sylvania,* but although he was now creating works that people were interested in seeing, and buying, he was not a prolific artist. Every canvas took him months, sometimes years, to complete.

The Brotherhood had finally attained the success they were seeking, but it came at a time when they had dissolved of their own accord. Woolner had left for Australia, and Collins had resigned in the heat of the critical controversy. By 1854, the Brotherhood was at an end. Christina Rossetti, Dante's sister and fellow artist and poet, wrote:

> *The PRB is in its decadence*
> *For Woolner in Australia cooks his chops,*
> *And Hunt is yearning for the land of Cheops.*
> *D.G. Rossetti shuns the vulgar optic:*
> *While William M. Rossetti merely lops*
> *His B's in English disesteemed as coptic.*

Lady Affixing Pennant to a Knight's Spear, Siddal, undated (Tate Gallery, London). Lizzie Siddal's attempts at painting were creditable. It was said that she was a vessel for the genius and passion of Rossetti and that it was this which enabled her to define her own talents.

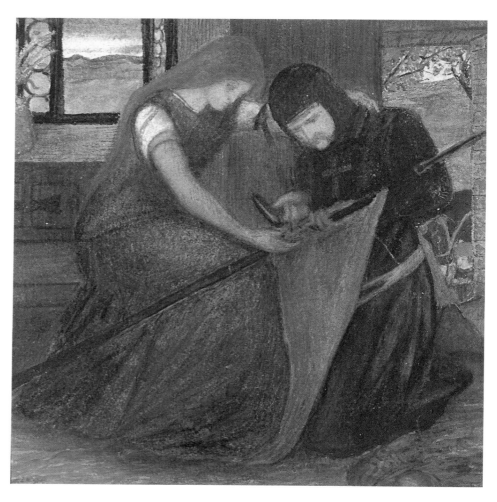

Calm Stephens in the twilight smokes his pipe
But long the dawning of his public day.
And he at last, the champion Great Millais,
Attaining Academic opulence,
Winds up his signature with ARA.

So rivers merge in the perpetual sea;
So luscious fruit must fall when over-ripe:
And so the consummated PRB.

Millais now decided to conform. He had returned to the bosom of the Academy, and had accepted an associateship, a fact which brought a smile of mirth to the lips of Rossetti, who muttered, 'So now the whole Round Table is dissolved.' Only Hunt and Hughes continued to paint in the original style of the Brotherhood, although Millais tentatively readopted it from time to time.

Millais maintained an uneasy relationship with Ruskin. A year earlier he had grudgingly agreed to travel with him to Glenfinlas in Scotland, where he painted the critic's portrait beside a stream. It was

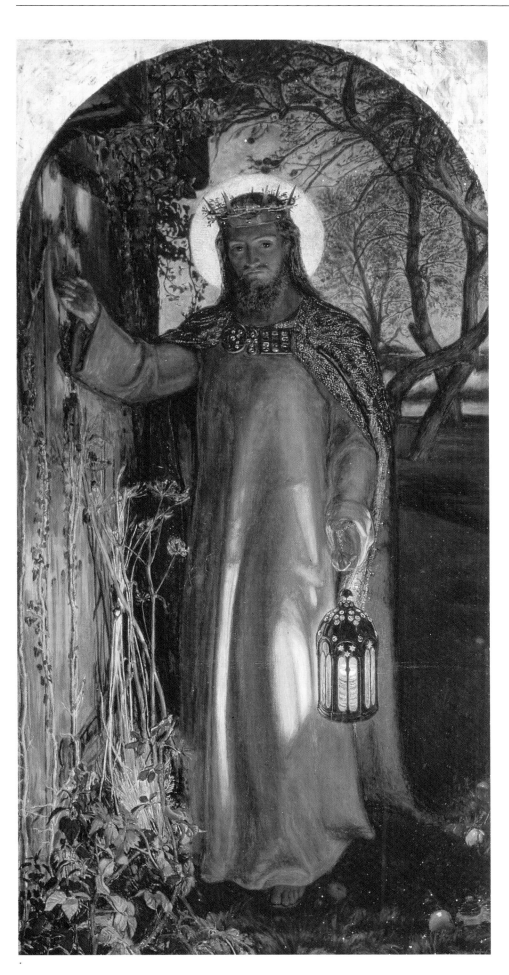

The Light of the World, Hunt, 1827-1910 (Manchester City Art Gallery). Hunt had always been deeply religious, and the moral message of this painting caused considerable speculation among the critics and public, who were concerned that the Brotherhood was Catholic, an unhappy vocation in Victorian England.

**The Emigrant's Last Sight of Home,
Redgrave, 1858** (Tate Gallery, London).
Redgrave often painted works with a
social conscience. Here, however, the
emphasis is on the beauty of the
landscape the emigrants are leaving
behind, rather than their plight.

an occasion of great excitement for Ruskin, who wrote to his father: 'He is very happy at the idea of doing it, and I think you will be proud of the picture, and we shall have the two most wonderful torrents in the world, Turner's *St Gothard* and Millais' *Glenfinlas*.' Millais stayed with Ruskin for some time, and they designed a church together, among other things.

Ruskin was married to Euphemia, a pert, pretty young woman known as 'Effie', but there was some indication that their natures were unsuited. Ruskin was a man who was passionate about learning, and whose life was filled with botany, art and scholarly interests. There is a story told that he was unable to consummate his marriage to a warm, flesh-and-blood woman because of her pubic hair. His studies had led him to believe that a woman was as smooth as a marble bust, and he was horrified to learn otherwise.

Indeed, the marriage vows were not fulfilled, and when Millais met Effie, she was desperate for warmth and attention, both of which the young, virile painter was willing to give her. They fell in love on that fateful Scottish trip and with the portrait unfinished, and Effie certain that she had no future with Ruskin, they both returned to their respective homes. There they maintained a cordial and perfectly respectable relationship until Effie was able to procure an annulment. Ruskin seemed not to mind his impotent label and he continued to be friendly with Millais, although he noticeably shifted his allegiance to Rossetti. In the Academy exhibition of 1856, Millais showed *The Blind Girl*, *Autumn Leaves* and *Peace Concluded*, all powerful works in which nature and poetry combined to spectacular effect. Ruskin was courteous about the paintings, showing to an avidly awaiting public that he was a sincere and unbiased critic. The next year, however, he attacked Millais' *A Dream of the Past – Sir Isumbras at the Ford*, perhaps believing the pressure was off and it was now safe to wreak his revenge. Shortly afterwards, Millais married Effie, a relationship which was to last for over forty years.

This was a time of flux for all the original members of the Pre-Raphaelites. While Millais sank into the mire of contentment, drifting towards art that was more commercially appealing, Rossetti had abandoned the Brotherhood's principles, and Hunt was growing increasingly dissatisfied. His religious integrity was gnawing at him, and he was anxious to move towards the light, closer to God and nature in the Holy Land. Literature had always been a favourite subject of Hunt's – in particular Shakespeare, Keats and Tennyson – and although he continued to be inspired by these works, he now started the first of many pictures with religious themes and very often symbolic and allegorical messages. *Druids* was the first painting in this vein, but he began to attach moral direction to all his work.

Hunt was as affected by 'stunners' as any of the Brotherhood. He fell for a beautiful Pre-Raphaelite model, Annie Miller, as heavily as

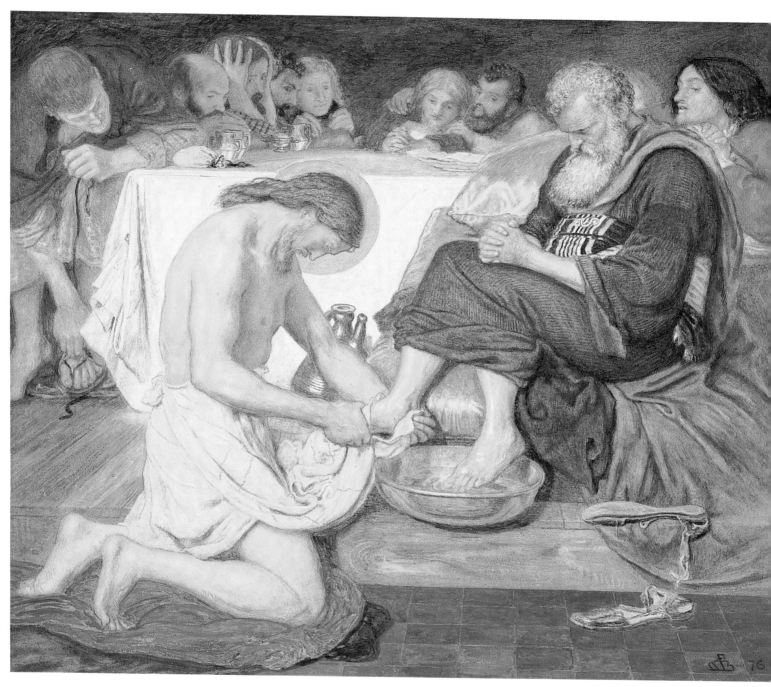

Rossetti had for Lizzie. Annie's religious aspirations did not match his, and he spent years trying to convert her to his kind of religious fervour, in the hope that they could be married. He was sadly let down, and remained unmarried until 1865, when Fanny Waugh became his wife. Following her early death, he married her sister, Edith, ten years later.

The Hireling Shepherd, with its clear, true colours and its moral message, had marked Hunt as a Pre-Raphaelite beyond compare, and this work acted as an inspiration to many of the Brotherhood's landscape painters. His colour work was outstanding, even today

Christ Washing Peter's Feet, Madox Brown, 1851-6 (Tate Gallery, London). This was first exhibited in 1852, but Madox Brown continued to retouch and recolour it for four years. Hunt and three of the Rossettis acted as models for this work.

**Take Your Son, Sir! Madox Brown,
1856-7** (Tate Gallery, London).
Considered by many to be cruel and
harsh, this painting addresses the issue
of illegitimacy. Madox Brown's wife
acted as his model for the work.

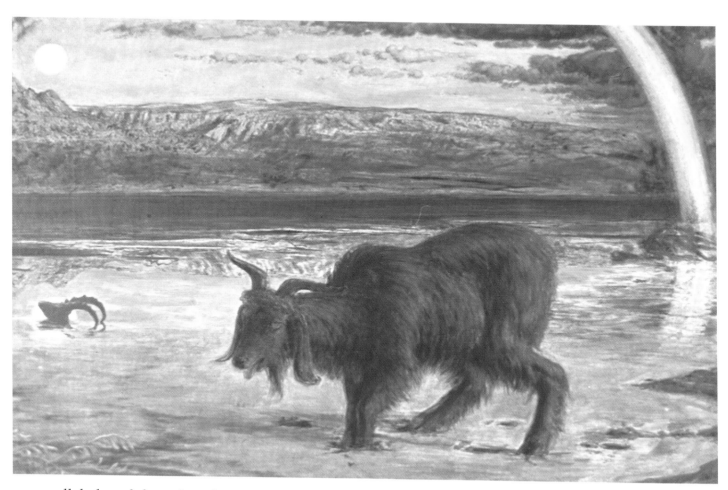

unparalleled, and the painstaking detail so elaborately wrought that it seems impossible for one man to have painted it. He was a perfectionist, and an extremely pedantic worker. In 1863 he wrote, 'I am so weary of work! ... I work and work until I feel my brain as dry as an old bit of cork, but completion slips away from me.'

Before his trip to the Holy Land, Hunt painted two important works, *The Awakening Conscience* and *The Light of the World*, thematically linked paintings representing the eternal issues of sin and morality. Christopher Wood wrote:

> *Both this* [The Light of the World] *and* The Awakening Conscience *are remarkable and highly individual pictures. There has been nothing quite like them in English art, either before or since. Their high technical finish and complex symbolism make them comparable only with early German or Flemish religious pictures. But although Hunt admired Van Dyck, Tintoretto and many other Italian artists, his own art was ruggedly insular and individual.*

The Holy Land was a natural progression for Hunt. He had reached the stage where he could no longer represent biblical subjects

The Scapegoat, Hunt, 1854 (Lady Lever Art Gallery, Port Sunlight). This was painted by the sea on Hunt's first trip to the Holy Land. The heat and the sand made working conditions grim, and the less-than-hardy goats he used as his models died one after another. In the end, Hunt returned to England with a goat, dozens of sketches and Dead Sea mud.

without accurately portraying their natural setting, and he set off in 1854 for the shores of the Dead Sea. Here he painted *The Scapegoat,* a painting that is as universally admired as it is hated. It represents the Talmudic tradition of forcing a sacrificial goat into the desert on the Day of Atonement. It took him weeks to paint, and even then he returned to England with goat, Dead Sea rocks and mud underarm to complete the work. His next painting of note was *The Finding of the Saviour in the Temple,* completed following a second trip to the Holy Land. It was purchased for an enormous sum of money and Hunt was able, at last, to live and paint without the fear of impending destitution.

The Brotherhood was finished, its main proponents spread across the globe both physically and metaphorically. There was, however, a new school of disciples, eagerly lapping up the principles of the old group. Hughes and Madox Brown were two of the most important, and they quietly went about their work, creating paintings of such startling depth and vision that it seems almost impossible that the artists were mere associates of the group. They made more of the original concepts than the initial idealistic three had ever done, and they are responsible, in many cases, for confirming the Pre-Raphaelite reputation.

There were other, new converts to Pre-Raphaelitism. Ruskin had grown increasingly approving, and in his *Academy Notes,* in 1856, he wrote: 'a true and consistent school of art is at last established in the Royal Academy of England'. Apart from Hughes and Madox Brown, there was Collins and Deverell, and two more academic painters, Augustus Leopold Egg and William Dyce, two late converts to Pre-Raphaelitism who had saved Hunt from penury following the series of disastrous reviews and exhibitions in the early 1850s. Dyce's *Titian's First Essay in Colour* was his first true Pre-Raphaelite work, and he adopted with great competence the dextrous technique of Hunt. His work is alive with tiny, extraordinarily realistic details, and the colours reverberate on a coolly lit background. Unlike most Pre-Raphaelites, however, he did not paint directly from nature, but worked from detailed sketches in his studio.

Henry Wallis also succumbed to the Pre-Raphaelite influence, but only a few paintings are completely in character. His *The Death of Chatterton* is a fascinating and moving portrayal of the dead poet, and was an instant success at the Academy exhibition of 1856. He went on to paint several other notable works, including *The Stonebreaker* (1857), which Ruskin called the painting 'of the year'.

Other Pre-Raphaelite disciples include Henry Alexander Bowler (1824–1903), Michael Frederick Halliday (1822–1869), William Bell Scott (1811–1890), Richard Redgrave (1804–1888) who was famous for his *The Emigrant's Last Sight of Home,* painted in gleaming Pre-Raphaelite

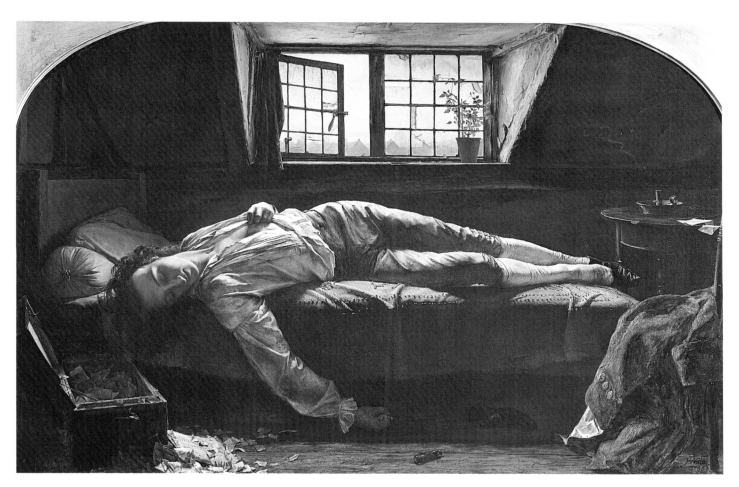

colours, Sir Joseph Noel Paton, William Lindsay Windus and Robert Braithwaite Martineau.

The Death of Chatterton, Wallis, 1856 (Tate Gallery, London). Henry Wallis' contribution to Pre-Raphaelite art was exemplified by this extraordinary work. He painted it in the loft where the poet Chatterton died, with a poet friend as model. The painting received enormous praise at the Academy in 1856, but Wallis failed to produce anything as significant again.

Hughes never budged from his devotion to the Brotherhood, and in 1856 he exhibited one of his greatest and best-loved pictures, *April Love*, which was, in Ruskin's words, 'lovely in colour, most subtle the quivering expression of the lips and sweetness of the tender face, shaken like a leaf by winds upon its dew, and hesitating back into peace'. Christopher Wood points out that the mood of Hughes' pictures is always sad, wistful and tender, and that his method of using the landscape setting to heighten and intensify the 'emotional situation of the pictures was a technique he used in practically all his pictures'. Hughes never allowed himself to become obsessed with dangerous women, like so many of the Pre-Raphaelites. He married in 1855, fathering five children in a warm and contented relationship, and managing to paint with the same passionate insight as his colleagues, despite his relatively calm life.

At this time Rossetti met two young and impressionable Oxford students, William Morris and Edward Burne-Jones. Arthur Hughes later joined them to paint murals on the walls of the Woodward debating room at the University Union Society. *Morte d'Arthur* was the

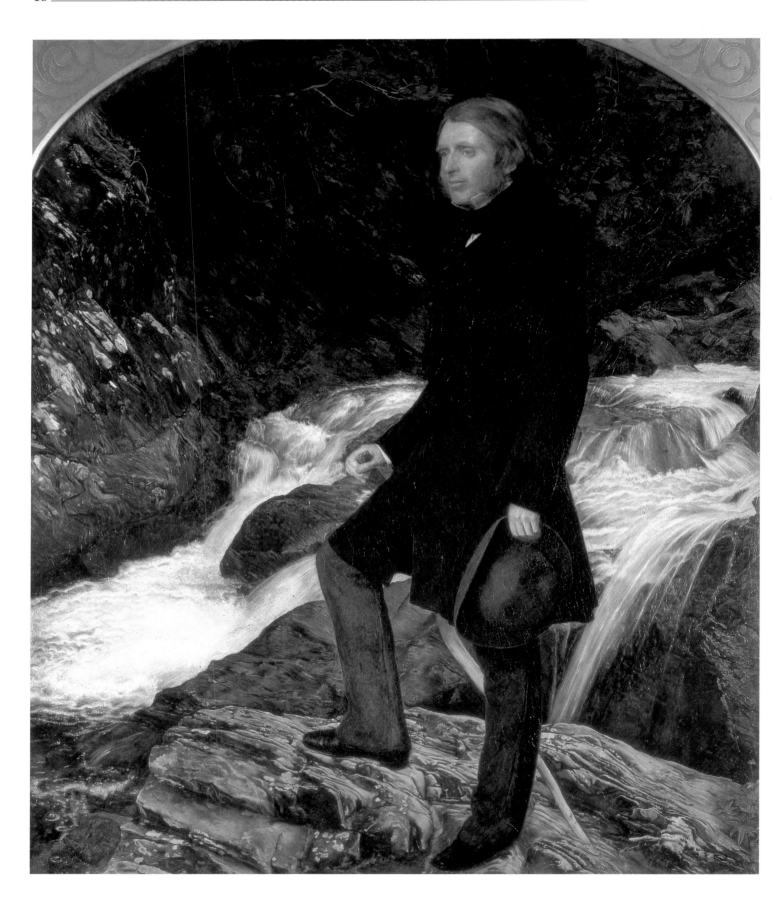

theme, and the four artists soon acquired the talents of John Spencer-Stanhope, Valentine Cameron Prinsep and John Hungerford Pollen. The worked together at all hours, laughing uproariously and engaging the attentions of much of the faculty and student body of the university. They were soon famous in their own right, Ruskin somewhat priggishly announcing:

> ... the fun of these fellows goes straight into their work; one can't get them to be quiet at it, or resist a fancy: if it strikes them so little a stroke on the bells of their soul, away they go to jingle, jingle, without ever caring what o'clock it is.

The whited-out windows were painted with wombats – the animal was described as 'a delightful creature' by Rossetti. But the whole, fantastic mural was painted on thinly white-washed brick walls, from which the distemper disintegrated almost immediately. They cheerfully shrugged their shoulders at this calamity, and continued the camaraderie in London's Red Lion Square, where Rossetti had found rooms for Morris and Burne-Jones.

Rossetti had been summoned home from Oxford because Lizzie was ill. He treated her growing illness with a kind of baffled acceptance, and in 1860, married her, although he did not make any attempt to make their new relationship monogamous. His new friends, Burne-Jones and Morris, married Georgiana Macdonald and Janey Burden respectively, and a new peaceful harmony took over their lives.

In the meantime, Lizzie grew more ill. She seemed to recognize that Rossetti had married her for lack of something better to do, and she sank deeper into depression, growing ever more dependent on laudanum. In 1862 she died from an overdose of this drug. She had given birth to a stillborn child in the last years of her life, and that, combined with an overriding jealousy of Rossetti's mistress Fanny, is thought to have been the cause of her suicide, although the coroner ruled it was accidental death.

Rossetti was wild with grief, his Beatrice dead, his inspiration, the great and fundamental figure of the Pre-Raphaelite woman gone forever. It was the end of an era for Rossetti. It was also the end of Pre-Raphaelitism in its purest form. The next stage of the movement would take it far beyond its original dogmas, into a new aesthetic stage characterized by greater realism and naturalism. It is this stage which featured some of the greatest Pre-Raphaelite works, and gave focus to the cluttered ideology of the Brotherhood. It was, however, only an extension of their tragic story.

Portrait of John Ruskin, Millais, 1854 (Private Collection). Ruskin was convinced that Millais would be the new Turner, and he wanted this portrait to be painted out of doors, in the spirit of the great landscape artist. Millais, however, opposed these ambitions and never finished the painting to his satisfaction.

CHAPTER 3

The New Aesthetics

The continuing development of Pre-Raphaelitism emerged as the Aesthetic movement, which gave wings to the original school of art and sent it soaring in new directions.

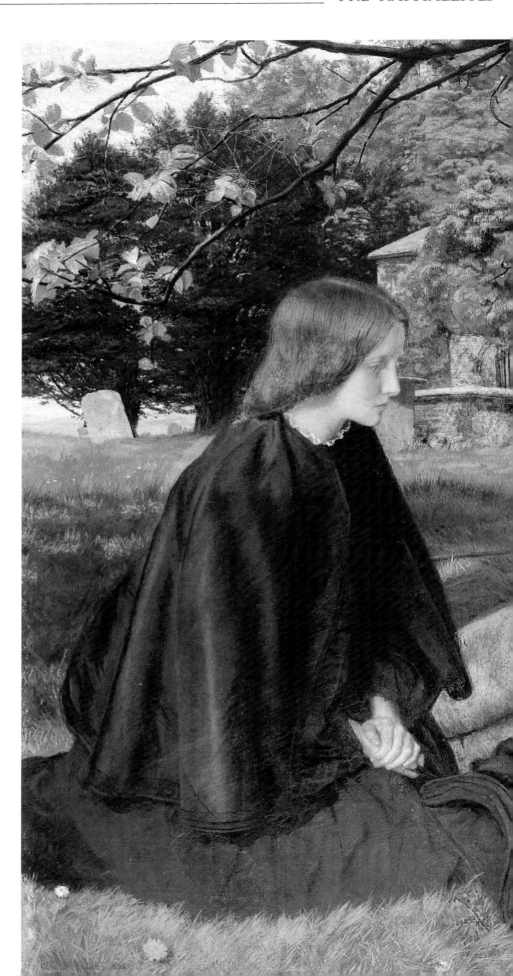

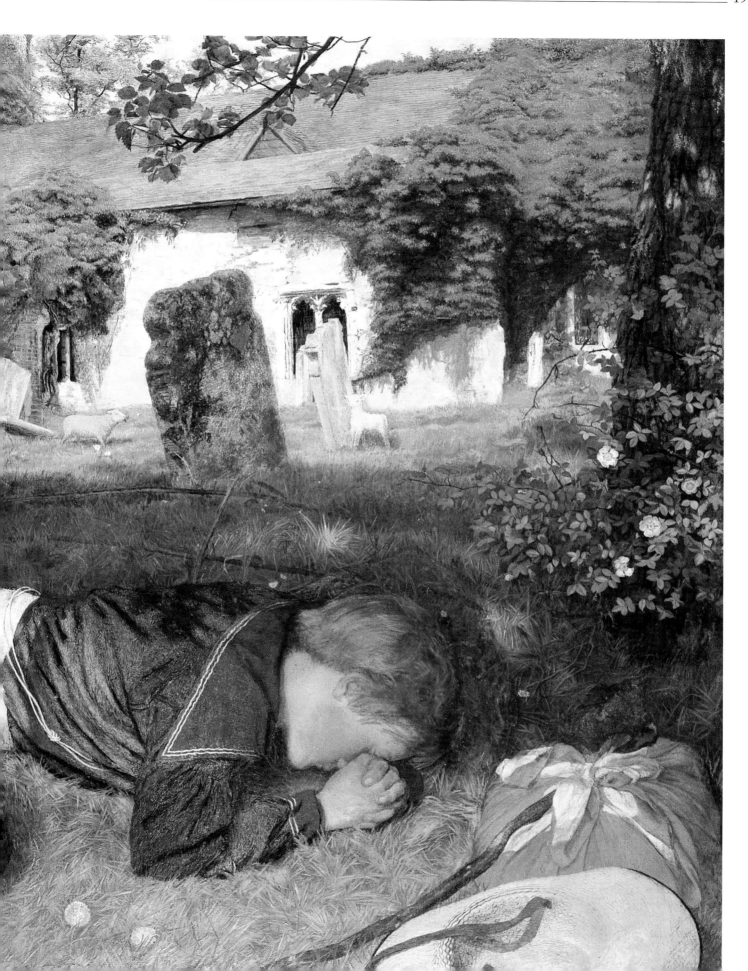

Overleaf:
Home from Sea, Hughes, 1863
(Ashmolean Museum, Oxford).
Hughes' typically heart-rending
themes never appear over-sentimental.
Here, a sister watches her grieving
brother, whose mother has passed
away while he was at sea. A nobility in
the composition and coloration
prevents it from being mawkish.

**Queen Guinevere (La Belle Iseult),
Morris, 1858** (Tate Gallery, London).
Morris' one finished painting is
thoroughly Pre-Raphaelite in style and
theme. It was painted as a tribute to his
own queen – Jane Burden – who acts as
his model.

The chief proponents of the new Aesthetic movement were Rossetti (who once again took his position at the helm), Edward Burne-Jones and William Morris. Their association dated from several years earlier and, by the 1860s, their friendship and combined artistic vision was confirmed. They sought to change the course of the Pre-Raphaelite movement, taking it further than painting and illustration, into other more diverse areas, including furniture, decorative arts, book design, architecture, and interior decoration.

William Morris was the prime instigator of the new ideology. Morris was a late convert to Pre-Raphaelitism, but he threw himself into its precepts with characteristic abandon. Morris was a short, thick-set man, with dark hair and a luxuriant, curly beard. A man of ideas and ideals, he was bouncing with energy, displaying enthusiasms for almost every aspect of the arts, from poetry and painting to decorative crafts. He had begun his education hoping to become an architect, but was persuaded by Rossetti to give this up and instead set himself the task of becoming a great painter. This career was rather short-lived, resulting in only one finished painting, *Queen Guinevere (La Belle Iseult)*. Rossetti continued to press him towards a career as a painter, but it was soon evident that he was wildly unsuited. It was while working on the Oxford murals that Morris realized his intrinsic talent for decorative pattern-making.

Morris was 'Topsy' to his friends, and along with Burne-Jones ('Ned') he became the centre of a group of intellectual and visionary young men. Like the Brotherhood before them, they shunned materialism and industrialism, finding beauty in the Middle Ages, in poetry and, at last, in the art of the Pre-Raphaelites. Rossetti had been their hero, and when he took them under his wing, before and after the Oxford incident, they responded with enthusiasm.

In Oxford Morris had met the latest 'stunner', Janey Burden, the daughter of a rather poor ostler. She acted as the model for Morris' *Queen Guinevere*, and a year later they were married, much to the dismay of Morris' family. He was, however, financially independent, and he and Janey set up their first home, a palace of art, in which Janey was very much queen. Christopher Wood explains the ideology behind the celebrated Red House in Bexley, Kent:

Finding that everything on the market was ugly and badly designed, Morris, Burne-Jones and their friends set about designing everything themselves – furniture, carpets, tapestries, stained glass and metalwork … out of all this activity, and through the prodigious enthusiasm and energy of Morris, grew 'the Firm'.

The Firm was in fact Morris, Marshall, Faulkner and Company, later to become Morris & Co., a design and manufacturing venture in

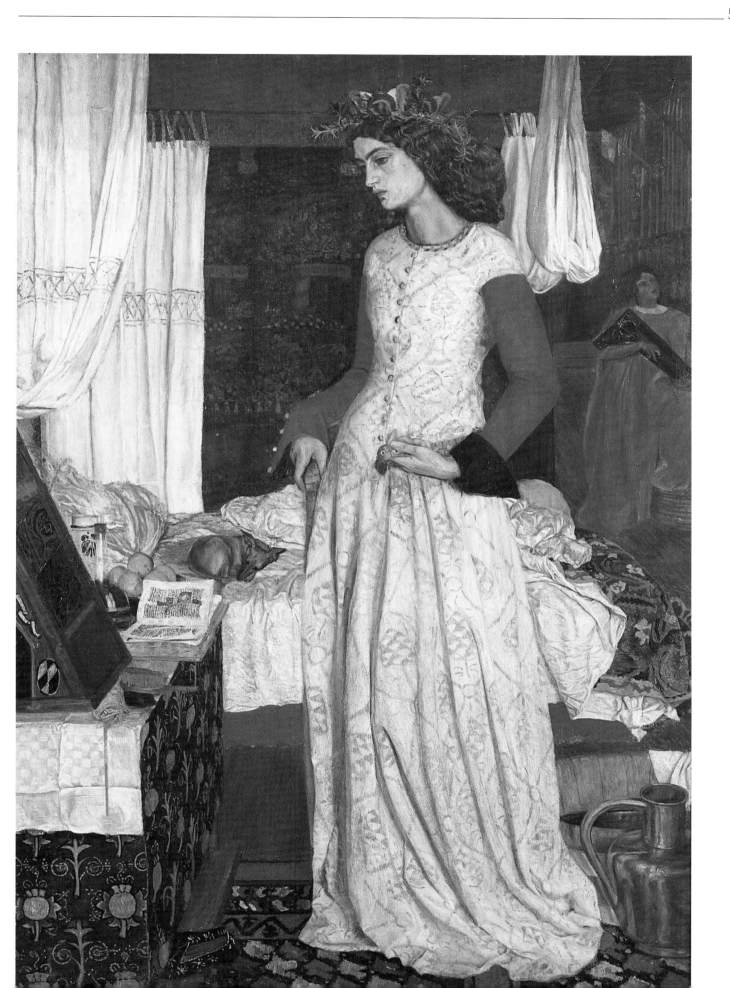

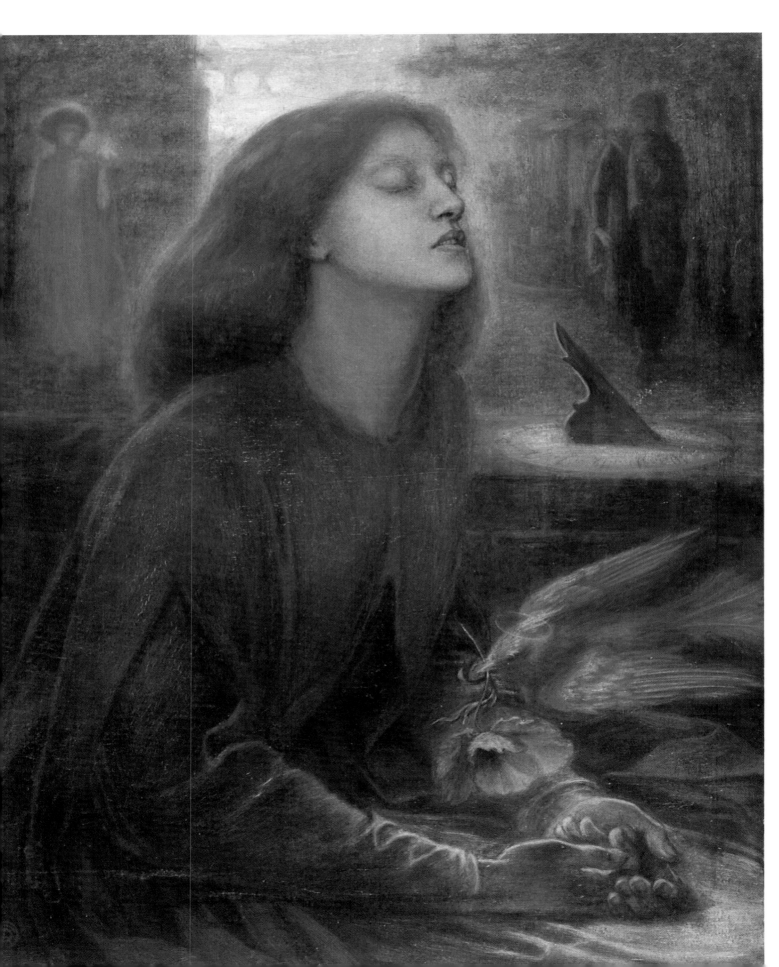

which almost all the Pre-Raphaelites were involved – from Madox Brown, Hughes, and William de Morgan, to Burne-Jones and Rossetti. It was this company which provided a focal point for the decorative talents of the Pre-Raphaelite painters, taking them and their influence into the next century.

Morris began wallpaper designing in 1862, and the first group was issued in 1865; these included *Daisy*, *the Trellis* and *Fruit*. He originated tapestries, in which Burne-Jones produced the figures and Morris created the background, and almost all the founding members made designs for windows.

Rossetti involved himself in the new Brotherhood, but he was a changed man after the death of Lizzie. He was one of the original shareholders in Morris' firm when it was founded, but he soon lost interest. He believed increasingly that his life had been wasted and he drowned his sorrows in alcohol and chloral to lift his depressions. He had grown quite fat, and unkempt in his appearance, looking much older than his forty-odd years. He moved from Chatham Place to Tudor House in Chelsea, and filled his house with an extraordinary entourage of bohemians, hangers-on, artists of some merit, and women, many of whom became mistresses and models. The poet Algernon Swinburne was one house guest, as was the author George Meredith and Rossetti's long-time mistress Fanny Cornworth. He had a menagerie of pets, many of which roamed or flew loose in the

Opposite:
Beata Beatrix, Rossetti, *c.* **1864-70** (Tate Gallery, London). Torn by grief at the loss of his Beatrice, Rossetti painted this as a memorial to Lizzie, who died in 1862. He painted it quite soon after her death, and came back to it five years later, when he was able to complete it.

The Wedding of Psyche, Burne-Jones, 1895 (Musée des Beaux-Arts, Brussels). This late Burne-Jones is fascinating but somehow sober. Henry James called his later work 'colder ... and less and less observed'. While there is something eerily romantic about this painting, its austerity lends it a kind of dignity.

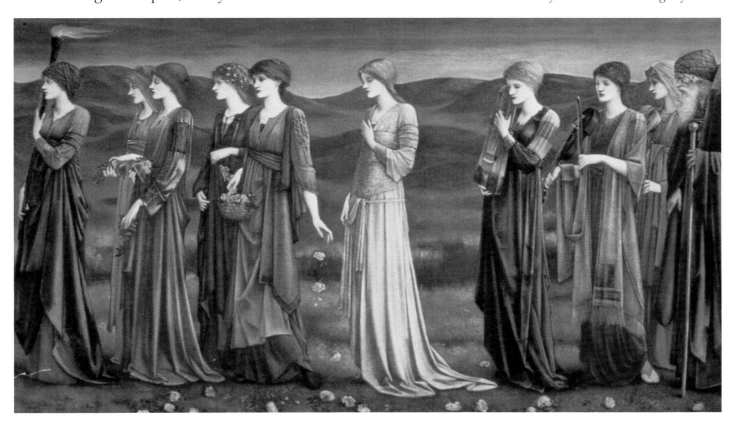

high-ceilinged corridors: owls, wombats, peacocks, lizards, wood-chucks, rabbits, parrots and once, even a bull, were all to be found.

Rossetti came to epitomize the English eccentric, but as he became lost in a drug-induced haze, he appeared not to notice his surroundings, and his memory began to fade. He became paranoid, developing a persecution complex. He attempted suicide in 1872, drinking a bottle of laudanum, just as Lizzie had, years earlier. When he recovered, he carried on in a morose fashion, becoming increasingly difficult to please, yet desperate for companionship and approval.

He experimented with different sorts of art. He had taken up illustration with woodcuts, and had illustrated a book of Tennyson's poems which led him into a new fascination with Arthurian legends. Medievalism was an interest shared by all the new school of Pre-Raphaelites, and one which was also appreciated by the great general public. He painted a large number of works from Malory, his first being *King Arthur's Tomb*, which is a small, dazzling watercolour in the characteristic jewel tones of the Brotherhood.

Rossetti's paintings throughout the 1870s are a tribute to his genius. Passionate outpourings of emotions, certainly, these paintings are nonetheless emblematic of his new maturity. He had worked in watercolours for much of his career, revelling in their bright subtlety, and the thin layers which could allow the flat expanses of white to shine through, illuminating his work. Now Rossetti changed to oils, adding a lustre and intensity to his work. When Lizzie died, he painted *Beata Beatrix*, a tribute to his wife and one of his most important Symbolist paintings.

New models moved in and out of his paintings, his home and his bed, and he pulled himself from the brink of paranoia many times. He had not shown any work at the Academy since that disastrous show of 1851, but he had been supported throughout most of his career by Ruskin, who undertook to buy all his pictures. He gave in to demands to show some paintings at the Pre-Raphaelite exhibition in Russell Place, London, in 1857, but he declined to show again, selling most of his work to wealthy patrons, many of whom bought his work unseen. He painted, during this difficult time, some of his greatest works, including *Morning Music, Proserpine, Daydream, The Bower Meadow, Veronica Veronese, The Blessed Damozel* and *Astarte Syriaca*.

There was a new model in Rossetti's life and she had inspired him with a fresh perspective. She was Janey Morris, and Rossetti was besotted. William Morris, in his typical hum of activity, failed, it appears, to notice that his wife was spending increasing amounts of time with his erstwhile friend and business partner. He still had the same awe for Rossetti's painting, never having been able to undertake it successfully himself, and he tended to leave matters of genius alone.

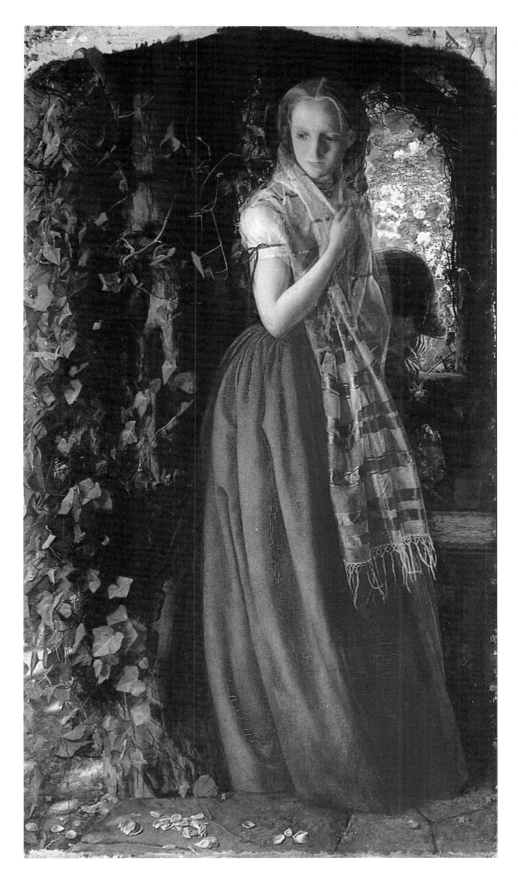

April Love, Hughes, 1855-6
(Tate Gallery, London). This was William Morris' favourite Pre-Raphaelite painting and he purchased it soon after seeing it for the first time. It has been suggested that Morris associated the colour blue with pleasure and desire, so the appeal of this painting is obvious.

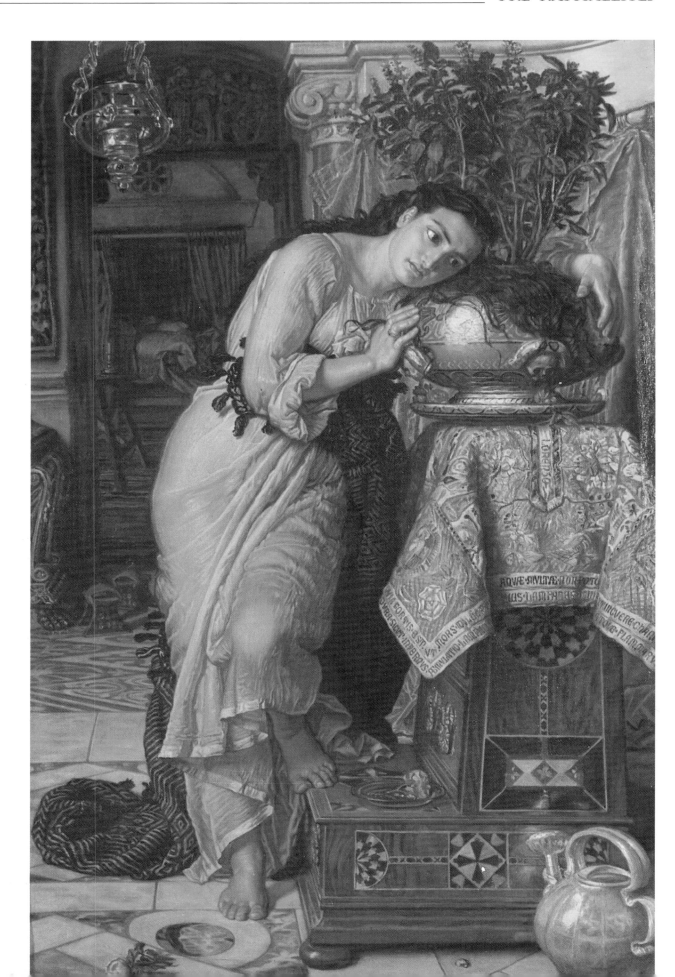

Janey, with her luxuriant dark hair, set in thick waves, became the embodiment of the next stage of the Pre-Raphaelite movement. Her hooded eyes stare out from almost all of Rossetti's later paintings, and her powerful, capable body and firm jawline make her a unique combination of sensuality and strength, just what Rossetti needed. She was a quiet, composed woman, by most accounts, although others have her brimming with her husband's energy and insight. George Bernard Shaw called Janey, 'the most silent woman I have ever met', and she and Rossetti found enormous comfort in each other's company. Rossetti slid in and out of chloralic stupor, and made love to William Morris' wife when the fancy struck.

Millais, throughout this period, was pressing on with his own discoveries. Married life suited him well, and he grew to like the things which a good income accorded. As his family and his tastes expanded, so did his financial requirements, with, some say, disastrous effects on his art. Millais had always been an accomplished painter, able to paint whatever was required at some speed, and he threw himself into money-making ventures once the initial excitement of the Brotherhood had worn off. In 1852 he had shown *The Huguenot*, which was considered one of the last of his Pre-Raphaelite works, and after *The Blind Girl* and *Autumn Leaves*, little of the school's ideals are reflected in his work. He became preoccupied with literary, historical and genre pictures, many of which attained critical success. *The Black Brunswicker* was one such painting, and from there he began to paint society portraits, which earned him enormous amounts of money but compromised severely his integrity and originality.

Millais denounced the Brotherhood, cheerfully dismissing it as a childhood foible, but he continued to call upon the artistic advice of his friends from that time, in particular Arthur Hughes, who acted as an adviser on more than one occasion. When Millais became swept away by sentimentality in his art, Hughes would often gently point him in a different direction, and in this way Millais was saved from complete commercial usurpation. He was making a veritable fortune from his painting – somewhere in the region of £30,000 to £40,000 – and he was loath not to investigate the possibilities of increasing that figure. He painted Scottish landscapes, like *Chill October* (1870), while his paintings of children, such as *Bubbles* and *Cherry Ripe*, would become famous around the world.

Millais was no longer Pre-Raphaelite, and he veered in a direction which contrasted starkly with the movement. He was a man of simple tastes, no intellectual, but nor did he pretend to be. He enjoyed music, travel writing and the occasional novel, but all of the high-minded ideals explored by the Brotherhood were clearly passing fancies. He seemed to feel intrinsically that the best painters were those who painted beautiful works of art. He argued with Hunt that the greater

Isabella or the Pot of Basil, Hunt, 1867 (Laing Art Gallery, Newcastle). Another Pre-Raphaelite painting based around a Keatsian theme, this work is richly ornamented and emblematic of Hunt's maturing style. His first wife, Fanny Waugh, was the model for this painting but she died before it could be finished.

King Cophetua and the Beggar Maid, Burne-Jones, 1884 (Tate Gallery, London). Inspired by Tennyson's *The Beggar Maid*, this painting was also exhibited at the Grosvenor Gallery in 1884, becoming one of Burne-Jones' most famous paintings.

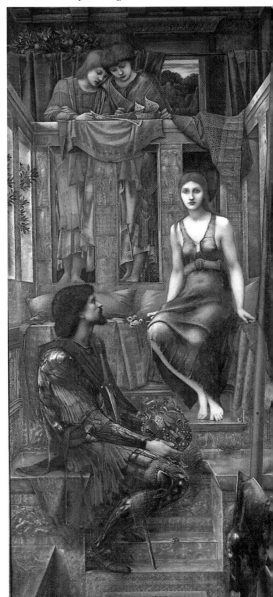

artists produced less socially acceptable works. He said, ' ... the portraits of Titian, Velázquez and Van Dyke are *severer* and are therefore not [acceptable] ...' He said to Hunt, 'You argue that if I paint for the passing fashion of my day my reputation some centuries hence will not be what my powers would secure for me if I did more ambitious work. I don't agree. A painter must work for the taste of his own day.' He backed down from his stance against contemporary commercial artists, and even finished Landseer's last painting, which had remained uncompleted upon his death. That would once have been heresy within the Brotherhood. Millais reaped the benefits of this stance: in 1880 a degree had been conferred upon him by Oxford University and in 1885 he accepted a baronetcy.

Hunt, however, found this new commercialism a bitter twist to the Pre-Raphaelite vision. He had moved in directions so different from Millais' it is surprising they remained friends at all. *The Scapegoat* was followed by religious or biblical pictures with complex symbolic overtones. The *Shadow of Death* (1870–3) and *The Triumph of the Innocents* (1883–4) were painted with all the splendour of the Brotherhood but with a new moral seriousness. Although Hunt returned to literary themes in his later work, with Keats' *Isabella or the Pot of Basil*, and Tennyson's *Lady of Shalott*, he reverted to themes present in his earliest works. In 1888 he was still working on a subject that had first sprung itself upon him in the 1850s. It was *May Morning on Magdalene Tower*, depicting the Christian celebration of a festival with Druid origins. This work took over a year to paint after its three-decade conception, and he then returned once again to the East, where he painted *The Miracle of the Holy Fire*, which occupied him for nearly ten years. Hunt was fascinated by this scene of religious extremism, and although it took him years to complete, it lacks somehow the fervour for which he had aimed. His paintings are, however, elaborate and highly intricate, brimming over with extraordinarily vivid details. He took time from his work to write a history of the Pre-Raphaelite movement, to which he remained faithful, and although he presented his position within the group as being rather more inspirational than it was, it is nonetheless one of the most detailed and dogmatic works about the artists which exist.

Hunt went on to become one of the most significant religious painters in England. Christopher Wood, in The *Pre-Raphaelites*, notes:

> ... the solidity of his modelling is somehow reminiscent of the heavy oppressiveness of the worst kind of Victorian furniture. Hunt's religious pictures were symbols of Victorian faith; to our sceptical ... eyes, they seem too laboured, too sentimental and too evocative of the very kind of Victorian religiosity and humbug we have deliberately rebelled against.

The Blind Girl, Millais, 1856
(Birmingham City Art Gallery). Rossetti called this painting 'one of the most touching and perfect things I know', and it is, perhaps, Millais' finest Pre-Raphaelite work. Soon after this, Millais' work began to adopt a new commercial appeal.

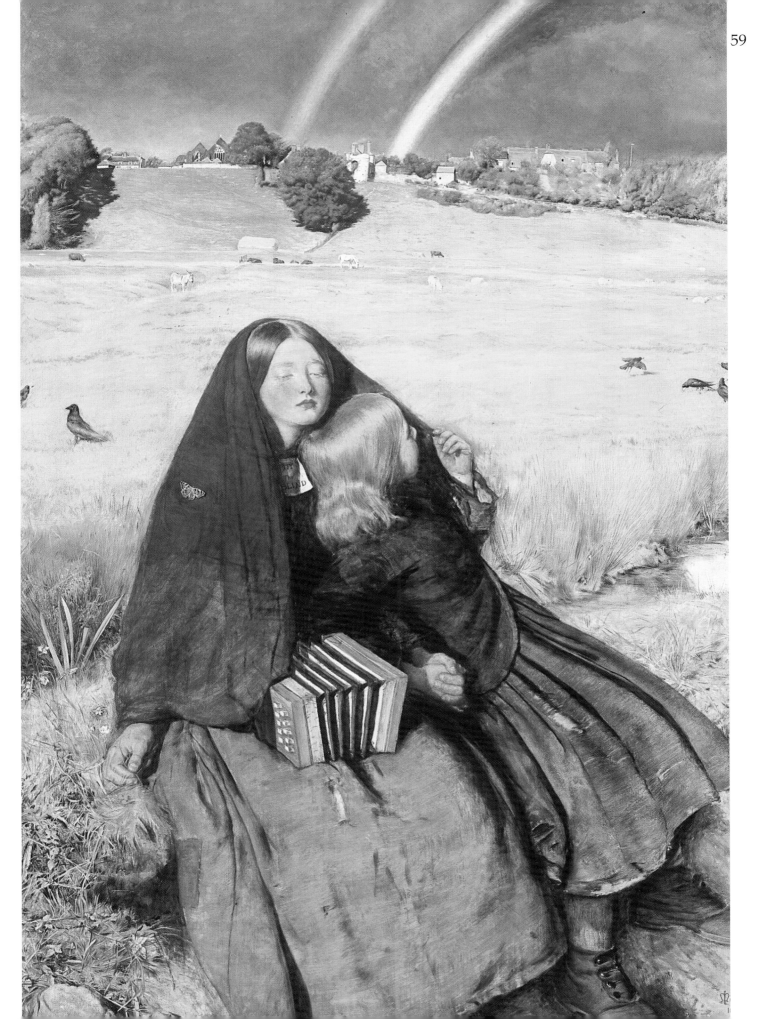

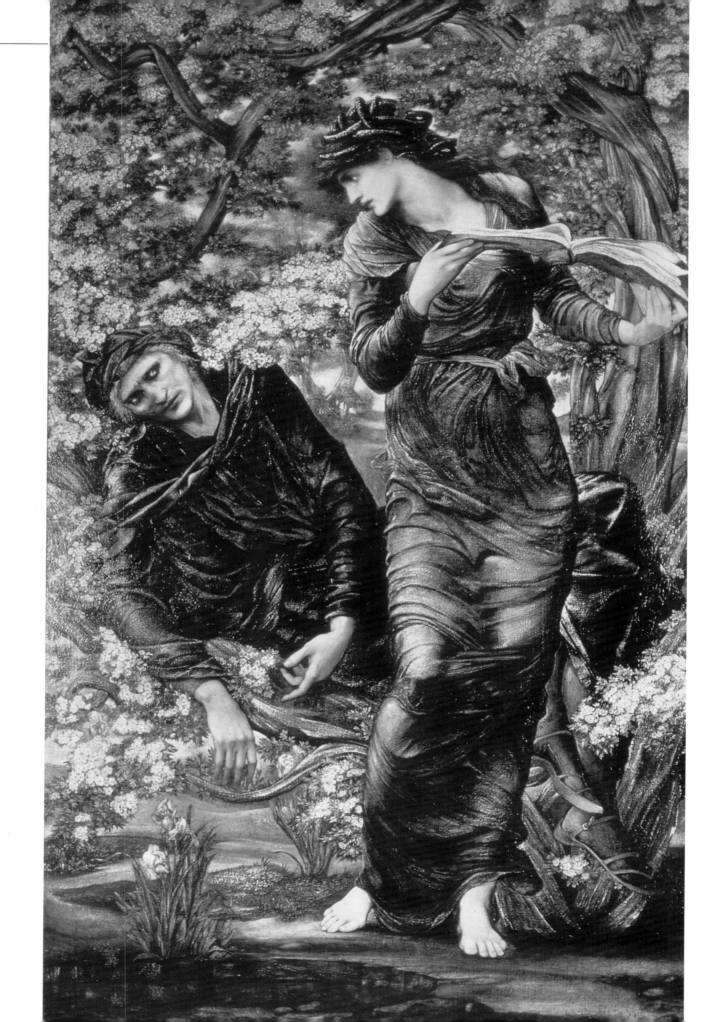

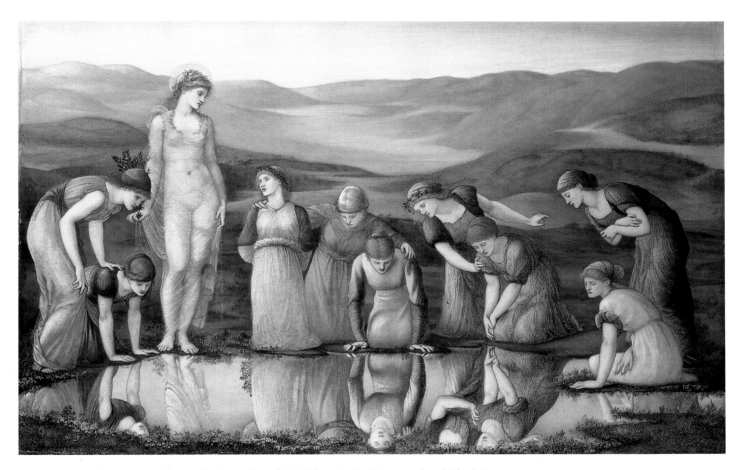

Burne-Jones was heavily involved in Morris & Co., and while his painting moved away from the influence of Rossetti and the Pre-Raphaelites, his decorative work remained a constant contribution to the growing reputation of Pre-Raphaelite design, which had centred around Morris and his new printing press, the Kelmscott Press, and his tapestry and stained-glass designs. A tall, sensitive man, Burne-Jones had been born to a poor family in Birmingham. He was hard-working, loyal and enchantingly straightforward in the midst of a rather over-zealous, hot-headed group of artists. He had planned a career in the church, but his talent for art was made evident and he became a recruit to Rossetti after seeing his work in 1855. Burne-Jones' Pre-Raphaelite work does, actually, form only a small proportion of his collection, and he was important in the development of many other schools of art, including Romanticism, the new Aesthetic movement and Symbolism.

Some of his greatest works include *The Beguiling of Merlin*, and a number of studies on *Fair Rosamund and Queen Eleanor*. A number of his great decorations for Morris & Co. inspired paintings, like *King Mark and La Belle Iseult* and *Cupid Delivering Psyche* (1867), which is one of his most famous works and wholly representative of his unique blend of Pre-Raphaelitism and Symbolism.

The Mirror of Venus, Burne-Jones, 1898 (Leicester Galleries, London). Henry James said of Burne-Jones, after seeing this work, 'his fertility of invention, his exquisiteness of work, his remarkable gifts as a colorist ... all these things constitute a brilliant distinction.'

The Beguiling of Merlin, Burne-Jones, 1874 (Lady Lever Art Gallery, Port Sunlight). This painting appeared at the newly opened Grosvenor Gallery, which none of the original Brotherhood attended. Because of this, Burne-Jones became synonymous with the movement and many of his works are now considered more Pre-Raphaelite in nature than those of the Brotherhood themselves.

Throughout the 1880s, Burne-Jones continued to work on themes which had been the soul of his paintings for most of his life. His greatest classical works included *The Garden of Pan*, *Danae* and *The Annunciation*. Then Arthurian and medieval legends captured his fancy, which also included some of the lovely fairy tales. From this time come works of glorious abandon, dreamlike paintings that are almost surreal in their extraordinary detail and vivid coloration. He painted *King Cophetua and the Beggar Maid* and *The Last Sleep of Arthur in Avalon*. Then there was his *Briar Rose* series, which included *Sleeping Beauty*.

Burne-Jones' finest work was shown at the 1877 exhibition at the Grosvenor Gallery, London. It was *The Mirror of Venus*, commissioned by F.R. Leyland and lauded as one of the most original paintings of the nineteenth century. In this painting his genius is celebrated in an unparalleled amalgamation of Pre-Raphaelite with classicist, of imagery and dream. The colours are pure Pre-Raphaelite, something many painters had moved away from following the deaths of the major exponents of the movement. Henry James called Burne-Jones, 'by far the most interesting thing in the Grosvenor Gallery', going on to praise him:

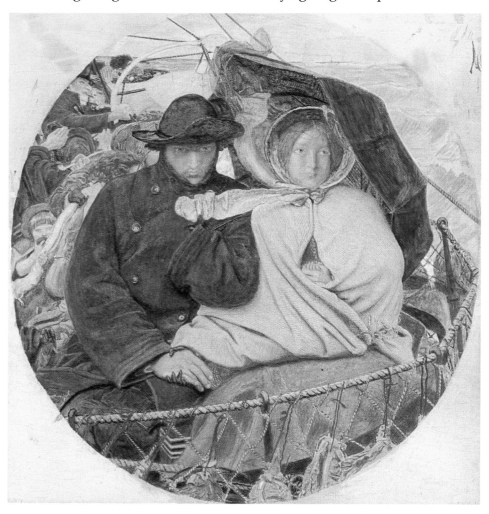

The Last of England, Madox Brown, 1855 (Tate Gallery, London). Madox Brown painted this work after bidding goodbye to his fellow Pre-Raphaelite, Thomas Woolner, who emigrated to Australia following the breakup of the Brotherhood. The man in the painting is Madox Brown himself, and the lady seated next to him his wife, Emma.

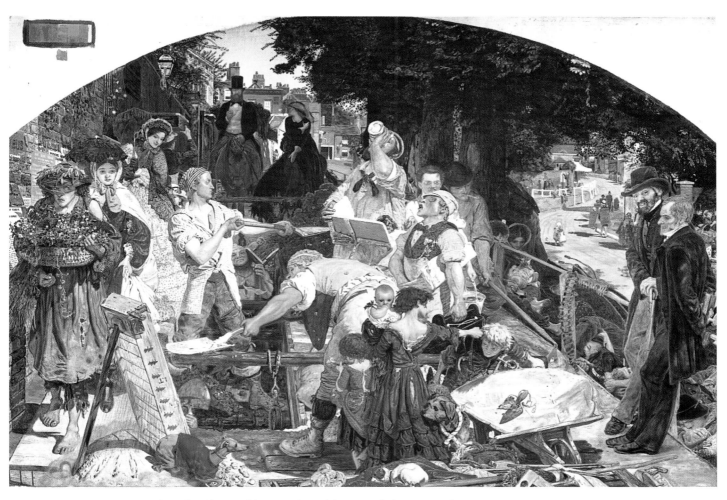

His imagination, his fertility of invention, his exquisiteness of work, his remarkable gifts as a colorist ... all these things constitute a brilliant distinction.

Work, Madox Brown, 1852-65
(Birmingham City Art Gallery). Madox Brown was an intensely democratic man and this painting, which took over twelve years to complete, is an allegory of the dignity of work. Many of his friends and associates were used as models.

Burne-Jones' own contribution to Pre-Raphaelitism was often unstated. His early works had been thematically based on medieval and literary material, and his technique developed after Giorgione and Florentine art. This, combined, with the influence of Rossetti, created a poetic and often mystical approach to painting which characterized the later stages of the Pre-Raphaelite movement. From the mid-1860s onwards, Burne-Jones was no longer able to paint exclusively in the style of the Pre-Raphaelites: it was too burdensome, extremely time-consuming, and clearly not reaping financial rewards. Burne-Jones had suffered poverty for most of his early life, and he vowed that it would not happen again. His new professionalism does, however, mark the end of his major influence on and association with the Pre-Raphaelites.

Remaining constant to his idealistic view that artists should stay true to their art, and not to contemporary tastes, Madox Brown was

still struggling. For over fifteen years he painted in an entirely Pre-Raphaelite style, and up to the mid-1860s every one of his paintings was true to nature, with a realistic subject matter painted on the now famous wet white background. He worked through extraordinary conditions, through the death of his wife, a stream of bad press and the poverty that resulted. It was a slow task: like Hunt he often took years to complete a canvas. In particular, his famous *Work* took him over twelve years to paint, and his explanation for the significance of the symbols and iconography of the painting fill five pages of the exhibition catalogue. He was a socially conscious painter – art did not, for him, represent a means by which he could become rich. He did grumble, however, about the high prices paid for the works of the other Pre-Raphaelites, and it became necessary for him to undertake more commercial work from time to time to support his young family.

Madox Brown had a dogged appreciation for realism, and another socially conscious painting, *The Last of England*, features the emigration of a middle-class family. He was painstakingly attentive to detail. He said:

> To ensure that peculiar look of light all round which objects have on a dull day at sea, it was painted for the most part in the open air on dull days, and, when the flesh was being painted, on cold days. Absolutely without regard to the art of any period or country, I have tried to render this scene as it would appear.

Work finally offered Madox Brown some financial security, and he relaxed slightly, taking on some design work for Morris & Co., and teaching at the Working Men's College in London. The last part of his career was mainly centred around twelve murals, commissioned by the city of Manchester to hang in the town hall. When he died in 1893, he was an important and powerful exponent of the Pre-Raphaelite movement. Although he had never actually joined the Brotherhood, he represented it supremely.

Arthur Hughes, by this time, had achieved considerable recognition for his work. Like Millais he had slipped into a comfortable existence within a large and happy family, and from the early 1860s he began to choose subjects which were slightly more sentimental than many Pre-Raphaelite brethren considered acceptable. *The Woodman's Child* (1860) and *Home from Work* (1860) are thematically based on the relationship between parent and child. His work became invested with idyllic sensibility – picturesque paintings of the English countryside, rippling with detail and softened, prettified nature. He abandoned some emphasis on detail of the early Pre-Raphaelite movement, but he maintained his poetic vision and exemplary use of colour, once again bringing the Pre-Raphaelites to the forefront of the critical

The Woodman's Child, Hughes, 1860 (Tate Gallery, London). Hughes' work became more mainstream after 1860, and he began to choose subjects of Victorian life as his themes, rather than those which were strictly literary or medieval. This painting, too, avoids being contrived, by its splendid detail and unassuming innocence.

establishment. The whimsical, ethereal qualities of his earlier work is replaced by a sturdier kind of Romanticism. Yet he, like Madox Brown, remained loyal to the movement, one of the few to do so. He outlived all of the Pre-Raphaelites but, following his work with Morris & Co., he faded into relative obscurity, still the case today. His suburban outlook denied him his proper place within the group.

The new Aesthetic movement burgeoned under the distinguished leadership of Burne-Jones, who took over when Rossetti was

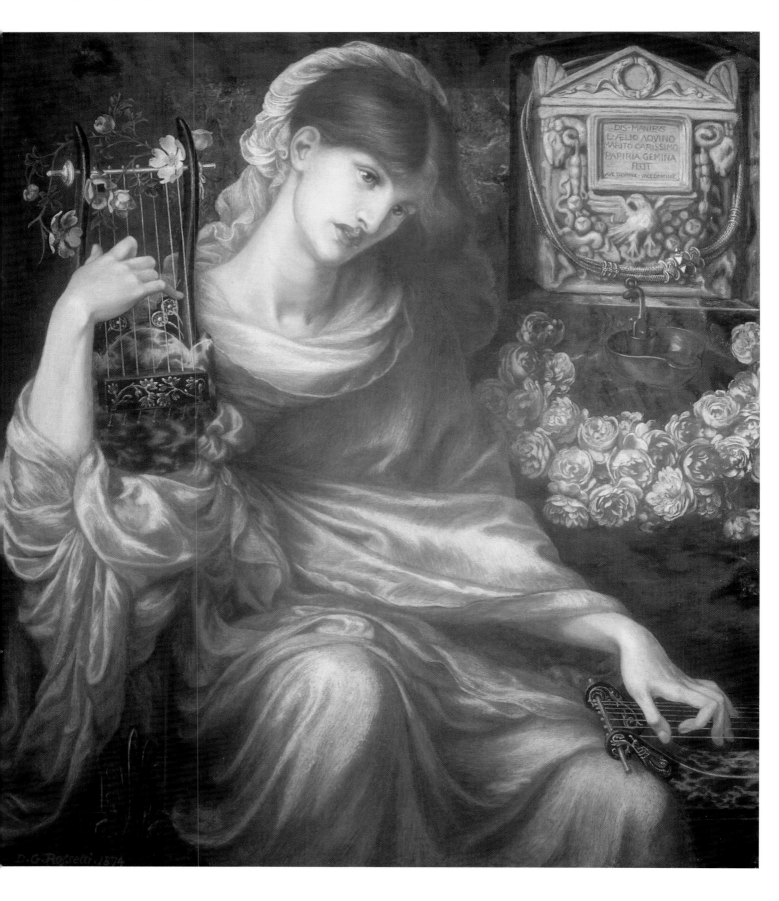

overcome by delirium. Madox Brown and Hughes all contributed to its force. Morris had become side-tracked by Socialism, which he adopted with a vengeance. It was a rather utopian Socialism, certainly, but it was a natural progression from the manifesto of his Arts and Crafts movement, and one of the final strings to the bow of Pre-Raphaelitism.

Ruskin had gone his own unmerry way, publicly damning the new architecture and the profound absence of culture. There was a famous libel trial with Whistler, whom he had condemned in one of his earlier critiques of art, and he lost conspicuously, with it many of his followers. He degenerated into a kind of confused madness by the end of the 1860s, his ordered mind finally succumbing to the pressures he made on it. However, this inspired a new generation of adoring followers, who called him their prophet, and clung to his crazy utterings with extraordinary tenacity.

The Pre-Raphaelite part of the Aesthetic movement was to draw to an unhappy close. Morris and Burne-Jones always remained friendly, but one by one the original Pre-Raphaelites dropped from the scene, some following new paths, others continuing in the old vein, but painting for a public who recognized them less and less. A new faction of Pre-Raphaelitism had developed and it attracted its own adherents. This was the new Classicism, and it carried the Pre-Raphaelite influence further than ever, but with some important omissions. Rossetti was floundering; Hunt was lost in religious reverie; Millais had painted *Bubbles*, which won him a glittering mainstream following, but he was a famous academician now, and he shuddered at his youthful dalliance in 'serious revolutionary art'. The spirit of the movement had become worn; imitators sprung up and tragic events continued to taint the lives of the original three. The Aesthetic movement had followed the Brotherhood in a glorious flowering of their imagination; it was a rich and vibrant period of their history and a natural progression from their later art. Henry James, writing about Burne-Jones in 1877, said:

> *It is the art of culture, of reflection, of intellectual luxury, of aesthetic refinement, of people who look at the world and at life not directly, as it were, and in all its accidental reality, but in the reflection and ornamental portrait of it furnished by literature, by poetry, by history, by erudition.*

It was a movement which grew to epitomize the thinking of the late nineteenth century, but when that thinking changed, when war and the new Modernism in the form of *art nouveau* and *art deco* appeared around the corner, it was discarded as casually as the fundamental culture and vision of the Victorians themselves.

The Roman Window, Rossetti, 1874 (Ponce Museum, Puerto Rico). Rossetti's relationship with Jane Burden was a catalyst in his eventual rift with Morris and a source of much anguish for his friend. Here Burden appears almost gilded, a reflection of Rossetti's deification of her.

CHAPTER 4

The Classical Movement and the Last Years

The later years of Pre-Raphaelitism were marked by two main traditions: the Aesthetic movement and the Classical movement. Many artists successfully combined the two to create a new, richer style; others broke into streams which carried the original concepts of the group into waters new and often deep.

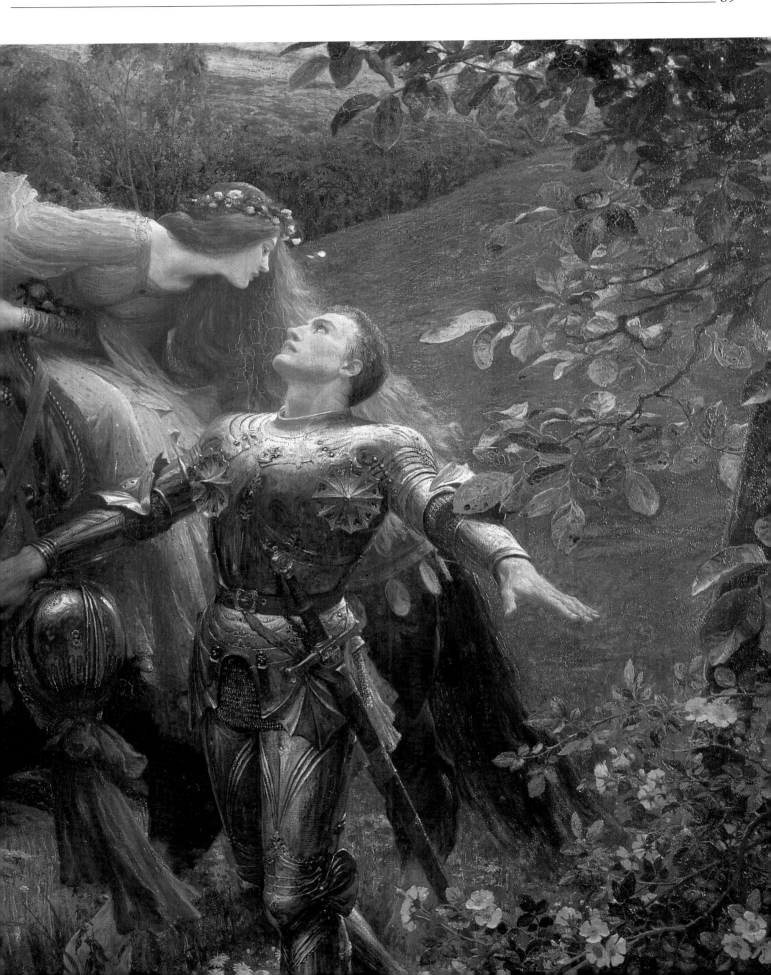

The Classical movement had grown in opposition to Pre-Raphaelitism, but strangely enough, many of its adherents adopted both the precepts of the new aesthetics of the Pre-Raphaelites, as well as the classical traditions, finding themselves members of two opposing factions within the developing Pre-Raphaelite consciousness. Frederick Leighton, George Frederick Watts, Edward John Poynter and Lawrence Alma-Tadema were the compelling force behind the Classical movement, and although some of them had experimented with Pre-Raphaelitism when it made its initial splash, they were vehemently against its ideals. Leighton planned to return English art to its classical heritage and, when he became president of the Royal Academy in 1878, he broke the art world into two bands, some say never properly to be reconciled. The Classical movement embraced classical Greek subjects, distinguished by magnificent coloration and rigorously maintained draughtsmanship.

The Aesthetic movement was much more eclectic, celebrating the individual talents of craftsmen, painters and artisans alike, and it was this movement which attracted most of the original Brotherhood, who sympathized with the aims of William Morris and Burne-Jones. Whistler, too, found himself a supporter of the camp, who pitted themselves against this reversion to the classical traditions, and used a much more diverse subject range for inspiration. William Gaunt, in *The Pre-Raphaelite Tragedy*, suggests that the Classical movement was in reality a part of the Aesthetic movement, and that Leighton was an aesthete. Burne-Jones and Leighton represented the romantic and classical ends of the same conviction. In the later work of the Pre-Raphaelites, this conviction became inextricably linked.

But while the battle for the state of art was being fought, other key events were occurring. Rossetti had moved for a time into Morris' country home, and his relationship with Janey flourished. She became even more an object of his obsession and his paintings acquired a dreamy, other-worldly quality. There is an overwhelming sensuality in his work; as ever, he painted to express his love, and it oozes from the canvas in exotic, ripe tones. That richness, however, became lurid in the later years of Rossetti's life, and his paintings developed an overriding melancholy. Some of his greatest works emerged from this period, including *Veronica Veronese*, and *The Blessed Damozel*, which was commissioned in the early 1870s but not finished until the end of the decade. By then, Rossetti had given up art and writing. His addictions had made him an invalid, and Janey Morris had slowly drifted back to her own life, gently welcomed by Morris who had seemed to accept her deviance from their unusual marriage. Fanny Cornworth, now married, had slipped in and out of Rossetti's life, igniting the fury of many of his friends and patrons. His intake of chloral had increased, washed down by copious amounts of whisky. Rossetti's family and

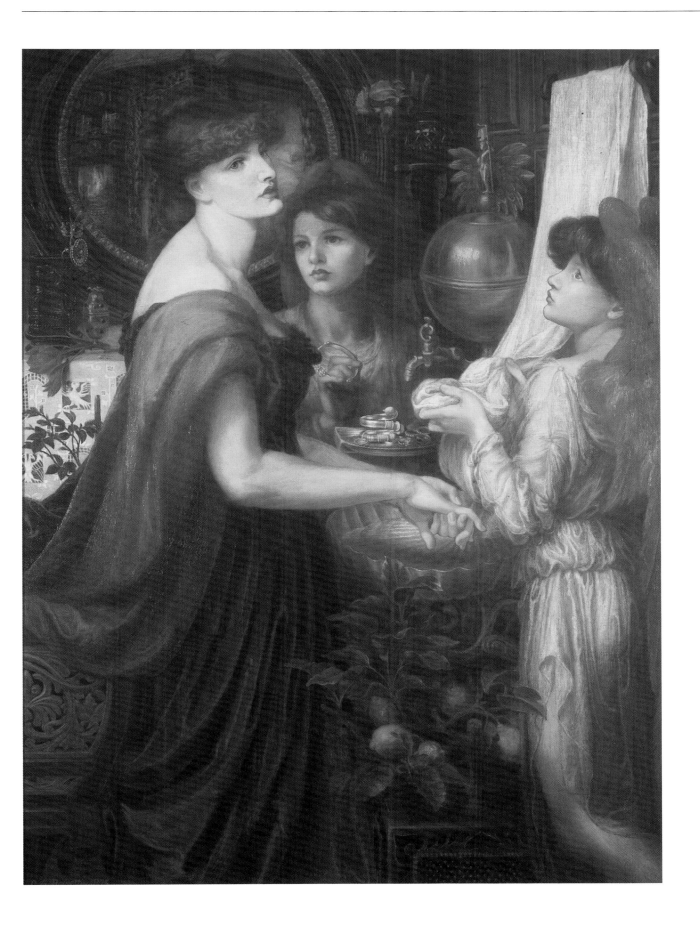

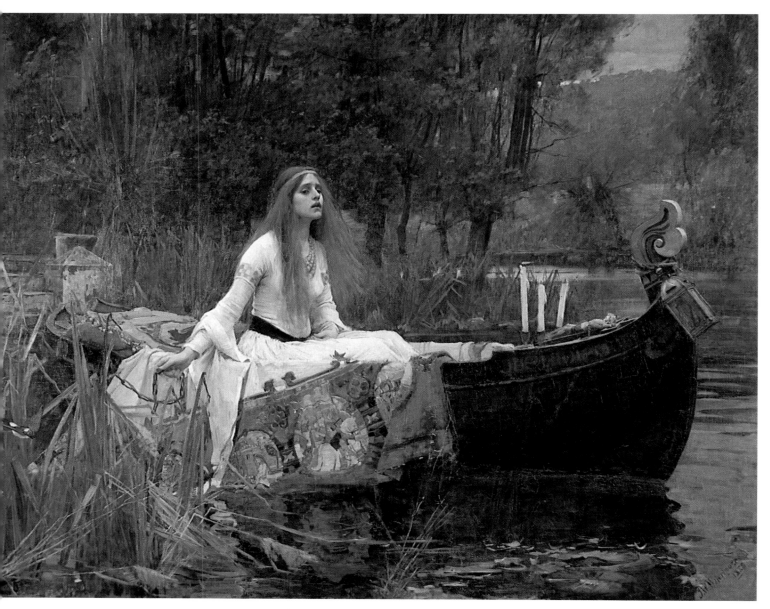

The Lady of Shalott, 1888, Waterhouse (Tate Gallery, London). Waterhouse became one of the greatest followers of the Pre-Raphaelite movement; he was instrumental in carrying their ideology into the twentieth century. The Tennyson theme was worked by many of the Pre-Raphaelites, and stylistically this painting reflects the influence of Hughes, and some early Millais.

friends appeared at his bedside, where they were told by the local doctor, 'Your friend does not want to live.'

Rossetti died on 9 April 1882, at only fifty-four years of age, his passion, his bursting effervescence spent. His was a life of tragedy, of impassioned and fervent love, riven by all-consuming sadness, uncontained rapture and spectacular vision. He was a man uncompromised by the world, glittering among his circle as the jewel in the crown. His death took the sparkle from the Pre-Raphaelite movement, although its course had altered long before. With him died the burning energy that had created it, the unflustered confidence that had maintained it, and the unfettered genius that had made it superb. His work, more Romantic than Pre-Raphaelite in his final days of painting, went on to inspire a whole new movement of Victorian Romanticism.

Rossetti's funeral was attended by only a few of the original group. He had fallen out with Morris several years earlier, when Morris had announced that he would buy out his colleagues. Morris had reached a point where he sought an individual sort of artistic existence, and although he was grateful for the support and input of his fellow artists, they had become a fairly diverse crew, with vastly different aims and styles. The Firm was his lifework and it was in his blood. He wanted to bring it to the peak of its promise. Ford Madox Brown was furious; he felt that Morris was grasping back a company to which they had all contributed, now that it was clearly thriving. He snorted at Morris' brand of Socialism, feeling it was undermined because he was rich and wanted to become even more so. Rossetti supported Madox Brown: he was certain that the latter had a point in his argument, even if it was not abundantly clear to him. He acted out of passion, in the spirit of the moment, but it terminated the friendship between him and Morris.

Millais at this time had, in Morris' eyes, become inestimably compromised. William Gaunt notes:

> *His work was a sort of prostitution, a titillation of shallow emotions in a shallow, brainless crowd of worldlings; symptoms, both, of something wrong with the social order. And if Millais represented the prostitution of art, Rossetti represented its dissipation, the indulgence of self with all the oppressive burden, the sterile misery that was bound to result: while Hunt was lost in theology trying to benefit the soul in some roundabout ineffective fashion.*

Morris felt that the Pre-Raphaelites had, by the time of Rossetti's death, lost their fighting spirit, their creative edge, and he backed away from them towards a new concept of art and aesthetics. His Socialism blossoming (while at the same time puzzling him; the lower classes made poor socialists, he felt, because they had not the dignity or courtesy to behave with reason), he became a lecturer, a writer of pamphlets and books in defence of art and architecture, proscribing the course for civilization to recover itself from the murky depths to which it had sunk. By 1896 Morris was exhausted. He was diabetic and he had done more in his life time than, it was said, 'half a dozen men'. Burne-Jones told of a day before his death when Morris leant forward at the breakfast table, his forehead in his hands. It alarmed Burne-Jones who had never seen Morris be anything but over-active. By the time he died, in 1896, at the age of sixty-two, Morris had formed a new ideal, an extraordinary printing press on which some of the most beautiful books in the world were produced, bringing the Pre-Raphaelite vision of beauty and its association with literature into the twentieth century, and a movement which reformed arts and crafts

the world over. His death marked the end of the Pre-Raphaelite dream. It also left Burne-Jones quite alone.

Hunt had spent the last decades of the nineteenth century in a spin of frustration and dissatisfaction. When the Grosvenor Gallery had opened in London – the perfect backdrop for the Pre-Raphaelites' work because of its fashionable atmosphere and its unquestioning support of the Pre-Raphaelite vision – all the main proponents declined the invitation to show there. Millais had become too entrenched in the Academy to bother with alternative venues, and Madox Brown, because Millais had been invited, felt that it would be too academic for their tastes. Hunt had little to show. He sold everything he finished because he desperately needed money, and the few meagre offerings he had for the gallery were inconsequential. Whistler and Burne-Jones came forward with some of their most spectacular works, and it was these artists whom the public came to consider as the very essence of the Pre-Raphaelites.

La Belle Dame Sans Merci, Waterhouse, 1893 (Hessisches Landesmuseum, Darmstadt). Even the later converts to Pre-Raphaelitism embraced literary subjects, and were devoted to their authentic rendering. Waterhouse was no exception and here Keats' poem is reworked with a lustrous elegance, the emphasis on realism.

The Vale of Rest, Millais, 1859
(Tate Gallery, London). This was
Millais' last true Pre-Raphaelite work,
before he began to paint in a more
commercial and socially acceptable
style. The intensely luminous quality
was achieved by painting pure colours
on to a canvas which had been prepared
with white paint, an idea born from
fresco painting.

Hunt was outraged by this, too. Here was a definition being given
to a movement which he had helped to initiate (in fact, in his mind, he
had initiated it single-handedly). The situation worsened when
William Michael Rossetti wrote a book which he claimed to be the
authoritative guide to the Brotherhood. Hunt was apoplectic with
rage. W.M. Rossetti's view was prejudiced, inaccurate and incorrect, he
railed. He had never grasped the meaning of the movement. Hunt
made the position clear to all. William Gaunt writes:

> Hunt now reduced the idea almost to vanishing point in his rejec-
> tion of fallacy [Rossetti's version]. It had nothing to do with the
> work of those affected Germans, with Herbert or Dyce among the
> English. It was not necessarily against the Academy. It had nothing
> to do with the Middle Ages. It was not inspired by Puseyism. It
> was, said Hunt 'it cannot be too clearly asserted ... the frank wor-
> ship of Nature, kept in check by selection and directed by the spirit
> of imaginative purpose'.

Ironically, the Pre-Raphaelite vision had never been so hotly
argued, debated and questioned until it was all over.

Hunt was awarded the Order of Merit and when he died, in 1910,
he was buried at Westminster Abbey, a frightfully proper end for the
firmest idealist of them all.

In 1885, Millais had painted a picture called *Bubbles* which had made him famous. It had been picked up by Pears, the soap firm, and used in their advertisements. Millais was originally horrified by this travesty of his art, but he soon realized that it was presenting his art to the masses, in a manner that was not at all indecent. It was, however, the subject of considerable debate within the art world, where many felt that Millais had been ultimately degraded, and with him the Academy and art in general. Bad press, or not, it brought attention to Millais, and there was no question that his work was exquisite, technically brilliant. He attracted a whole new school of followers, and in 1886 a Millais retrospective appeared at the Grosvenor Gallery. With *Isabella* placed beside his newer works, he looked rather shocked, and swiftly placed his earlier Pre-Raphaelite paintings in a room of their own. While he feigned horror that he could ever have painted such works, it was more likely that he despaired at the comparison between them and his newer, superficial paintings. He confided in a friend, ' ... you see me unmanned. In looking at my earliest pictures I have been overcome with chagrin that I so far failed in my maturity to fulfil the forecast of my youth.'

Later that year, Morris wrote, when he heard that Millais' Pre-Raphaelite painting *Vale of Rest* had been sold for an inordinately high price: 'Tis worth a cartload of the wretched daubs he turns out now.'

But Millais' fame grew, as his health deteriorated. He received honour after honour, but after a bad bout of influenza in the early 1890s, he was left almost unable to speak. He sensed this was serious and indeed it became worse over the next years. But as he grew thin, and his voice weaker, he continued to patronize the arts, taking note of new and exciting artists and illustrators who were fast becoming the new generation of art. He became the president of the Royal Academy for a brief period, from 1895, but his address could hardly be heard. He said to a friend, in 1896, as he pointed to his throat, 'It will kill me ... but I am ready and unafraid. I've had a good time ... a very good time.' In August 1896, he died, and was buried in St Paul's Cathedral.

A lavish memorial service paid tribute to his success – and what much of the art world now called his genius. No one drew attention to the division between his promise and the reality of his work; the charm of his painting was undeniable and there was no question about his talent. He could have remained an impoverished adherent to a cause which would, of course, have a natural end. He chose a happier course, one whereby he was fêted and received enough money to live in near opulence. He was a kind man; no one begrudged him his fame.

Most of the Pre-Raphaelites died in the last decade of the nineteenth century, never seeing the new dawn of their work, the renaissance which would follow. For years the Pre-Raphaelites were considered musty, stodgy Victorian idealists, and collections of their

works were hung in the galleries and homes of only the most stalwart art lovers. But their work had inspired a new school of art, one which fed upon the last remaining proponents and grew in size until it gained a recognized and respected following.

One important artist of this new following was John William Waterhouse, who is classed as one of the greatest Victorian painters after Burne-Jones, carefully entwining the Romantic movement with

By the Fountain, Stillman, 1883 (Private Collection). Marie Stillman (née Spartali) was one of the few women painters of note in the Pre-Raphaelite movement. She modelled occasionally for Rossetti, and her work shows his influence.

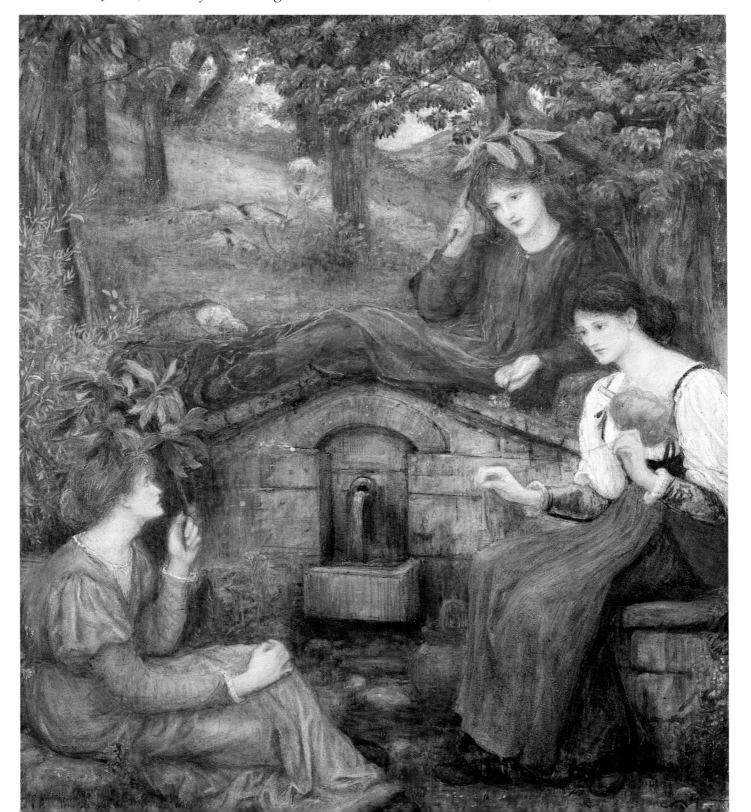

Pre-Raphaelite dogma to present works of spectacular clarity and vision. His *The Lady of Shalott* is still one of the favourite Pre-Raphaelite paintings of them all, together with other works like *Hylas and the Nymphs*, *La Belle Dame Sans Merci* and *Ophelia*.

Waterhouse had been born in Rome of artist parents, and his love of Italy was reflected in many of his early paintings, and in his devotion

to classical subjects. While Waterhouse is often considered a protégé of Leighton, he was, after the death of Burne-Jones, recognized for his creative genius, remaining one of the few admired and respected members of the Pre-Raphaelite movement. His paintings are a clever and ingenious reconciliation of both the classical and Pre-Raphaelite – and his work embodies much of the late Aesthetic movement – with elements of the classical, biblical, historical, medieval and literary. His work was more realistic than that of either Rossetti or Burne-Jones, but a dreamy, romantic quality pervades each work. He had a recognizable, individual style that hardly changed throughout his career. The work of Tennyson and Keats are favourite themes for his painting, and he would often produce two or three works based around the same poem or book. He was a quiet, unprepossessing man, with none of the private passions and turbulent home life that characterized many of the other Pre-Raphaelites.

Frederick Sandys was another follower of the later movement. One of Rossetti's pupils, he painted, like Rossetti, works in which the classically beautiful *femme fatale* was the central feature. He was, however, a much better artist than Rossetti and his technique and composition have been likened to early Millais, and Holman Hunt. Maria Stillman was also a disciple of Rossetti's although she was Madox Brown's pupil. One of the few women Pre-Raphaelites, she nonetheless embodied the movement in its later years and was instrumental in creating works that ensured its passage into the next century. John Spencer-Stanhope, Evelyn de Morgan, Walter Crane and Sir Frank Dicksee all flirted with Pre-Raphaelitism, and each has contributed to the development of the school.

Waterhouse remained the most famous and highly charged of the last days of the movement. Only he was able to work within the rigid definitions of the new aesthetic, combining classical, mystical and romantic within the boundaries of the Pre-Raphaelite creed. Others joined his ranks for brief periods, like John Liston Byam Shaw, and Edward Frampton, but Waterhouse alone soared above, the shy realist, the poetic genius with the unambitious loyalty to an art in which he believed with the very essence of his being.

The movement had, in reality, ground to a halt years earlier, but some of this new generation of painters were able to move quietly to the front, and ease it gently into the next century. The Pre-Raphaelites have only recently been given the recognition they deserve. Their story can be relished without knowledge of their work, their extraordinary skills, their remarkable use of colour; but their works are the crowning glory of an age-old tale. They are works so exquisite, so breathtakingly moving, so richly worked, that they have created for themselves a place in history that could rightly belong only to them.

La Belle Dame Sans Merci, Cadogan Cowper, 1926 (Private Collection). Frank Cadogan Cowper (1877-1958) was the last true Pre-Raphaelite, and here, he adopts a familiar Keatsian theme. His aggressive use of colour rejects the faded, dreamy pastels that had become emblematic of many later exponents of the movement – in particular, the work of Burne-Jones.

INDEX

Hunt, The Awakening Conscience, 1853
(Tate Gallery, London)

Millais, Mariana, 1851
(The Makins Collection)

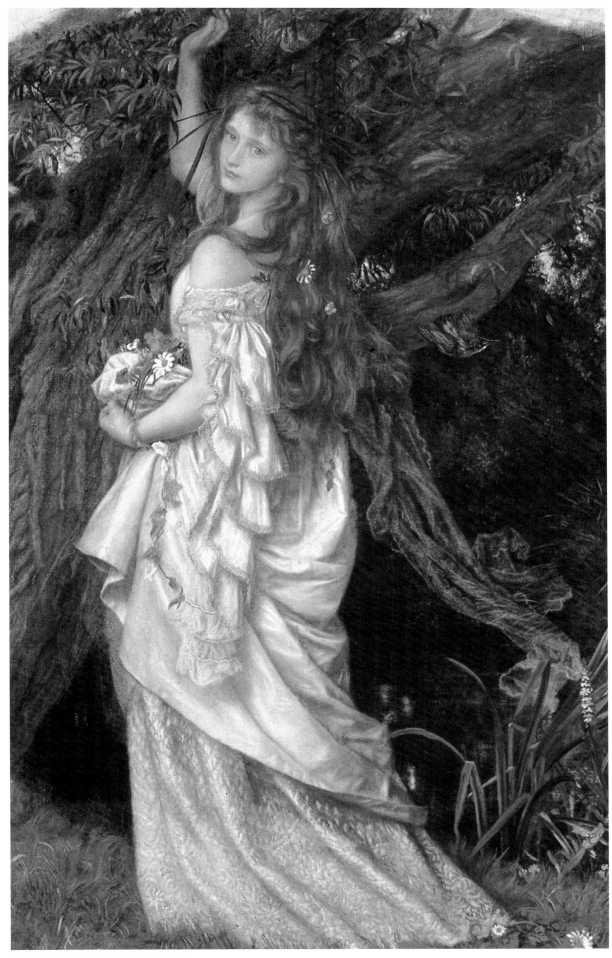

Hughes, Ophelia, 1865
(Toledo Museum of Art)

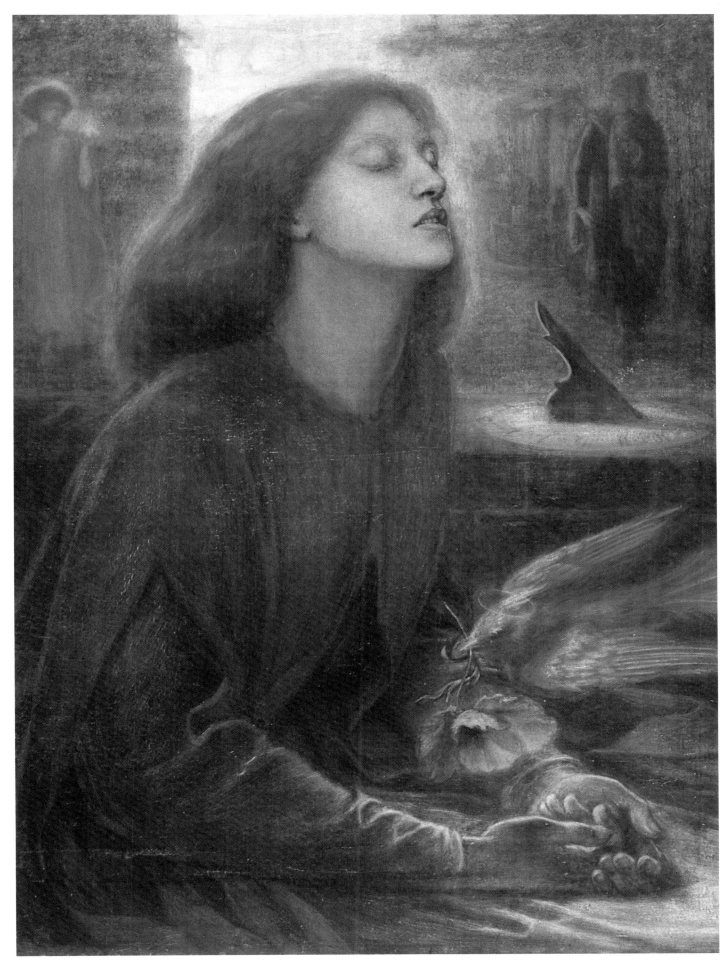

Rossetti, Beata Beatrix, c. 1864-70
(Tate Gallery, London)

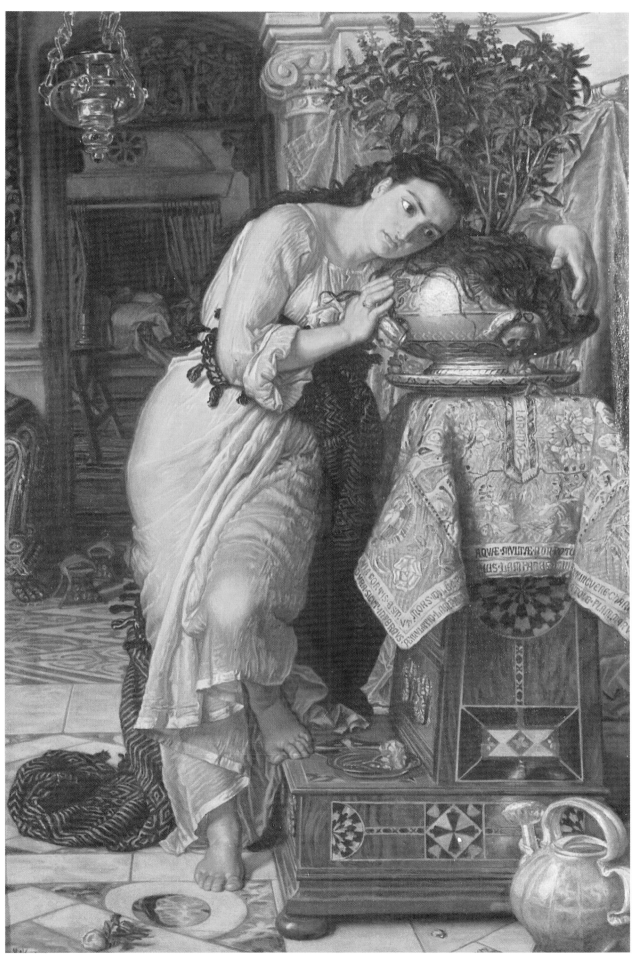

Hunt, Isabella or the Pot of Basil, 1867
(Laing Art Gallery, Newcastle)

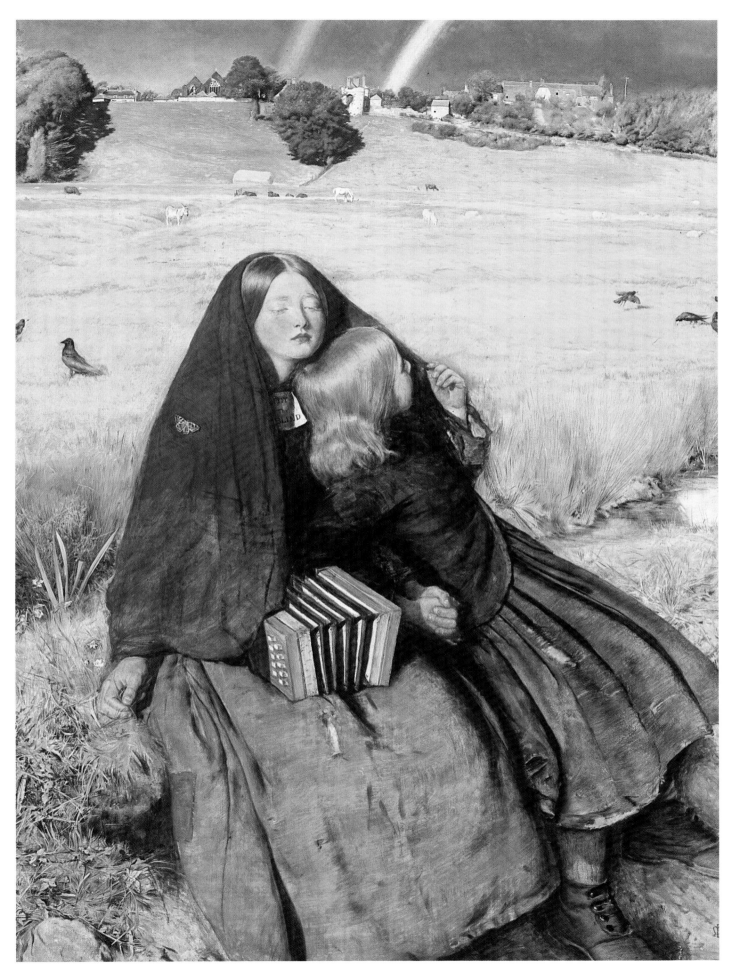

Millais, The Blind Girl, 1856
(Birmingham City Art Gallery)

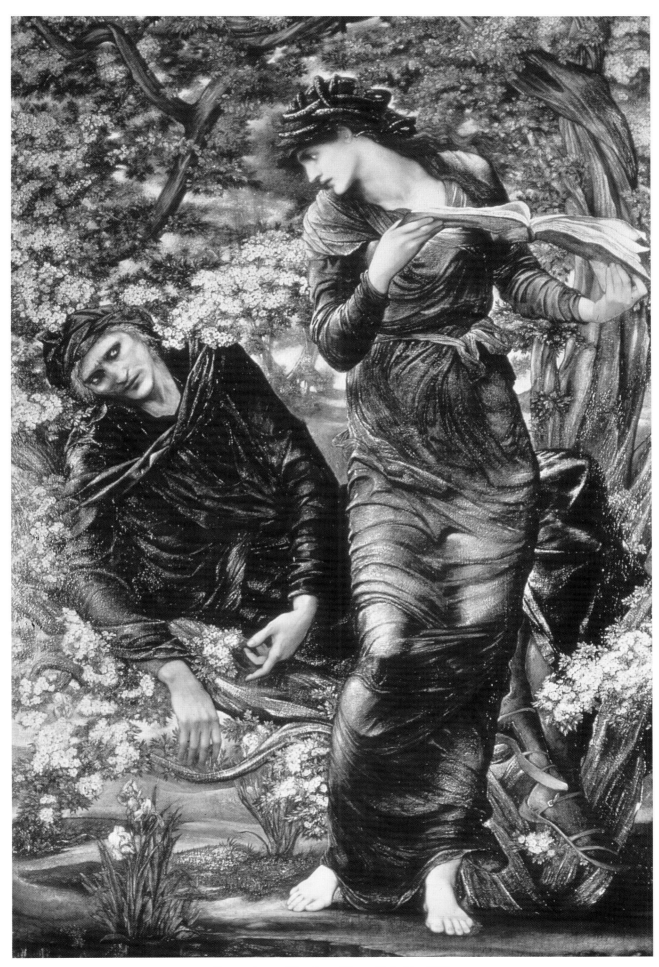

Burne-Jones, The Beguiling of Merlin, 1874
(Lady Lever Art Gallery, Port Sunlight)

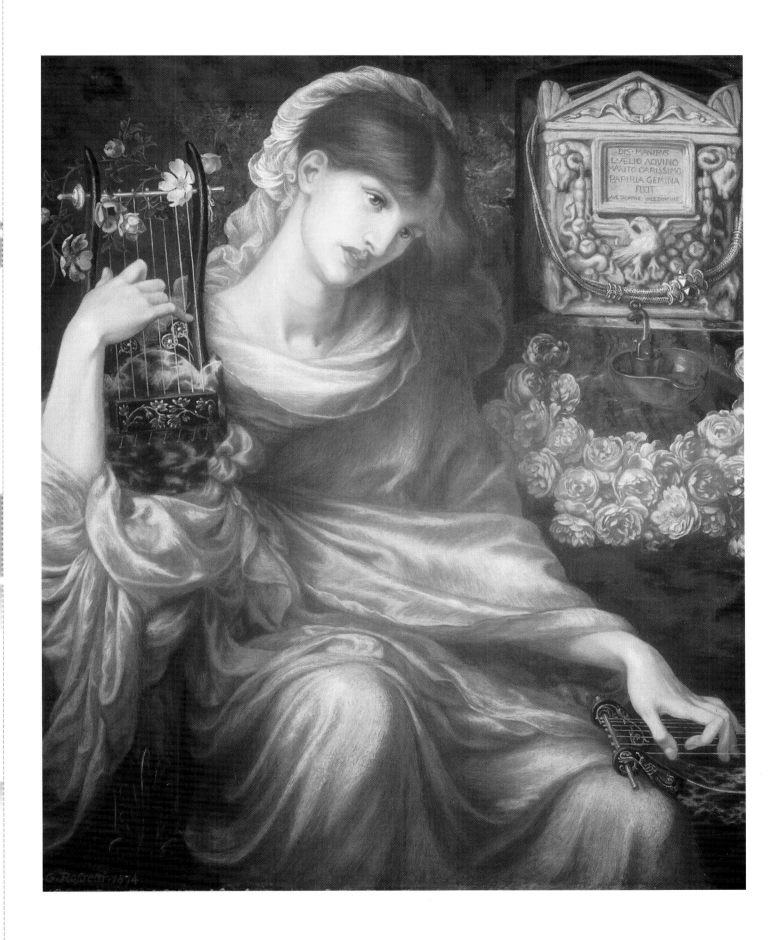

Rossetti, The Roman Window, 1874
(Ponce Museum, Puerto Rico)